ALGONQUIN SEASONS

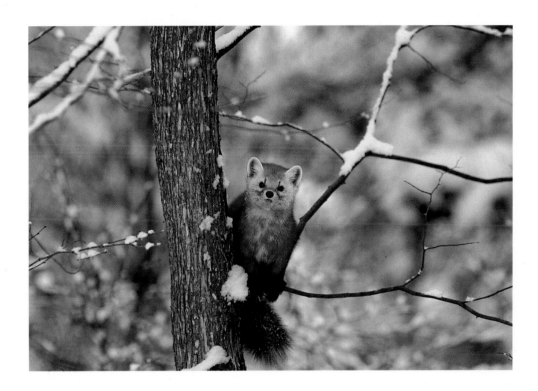

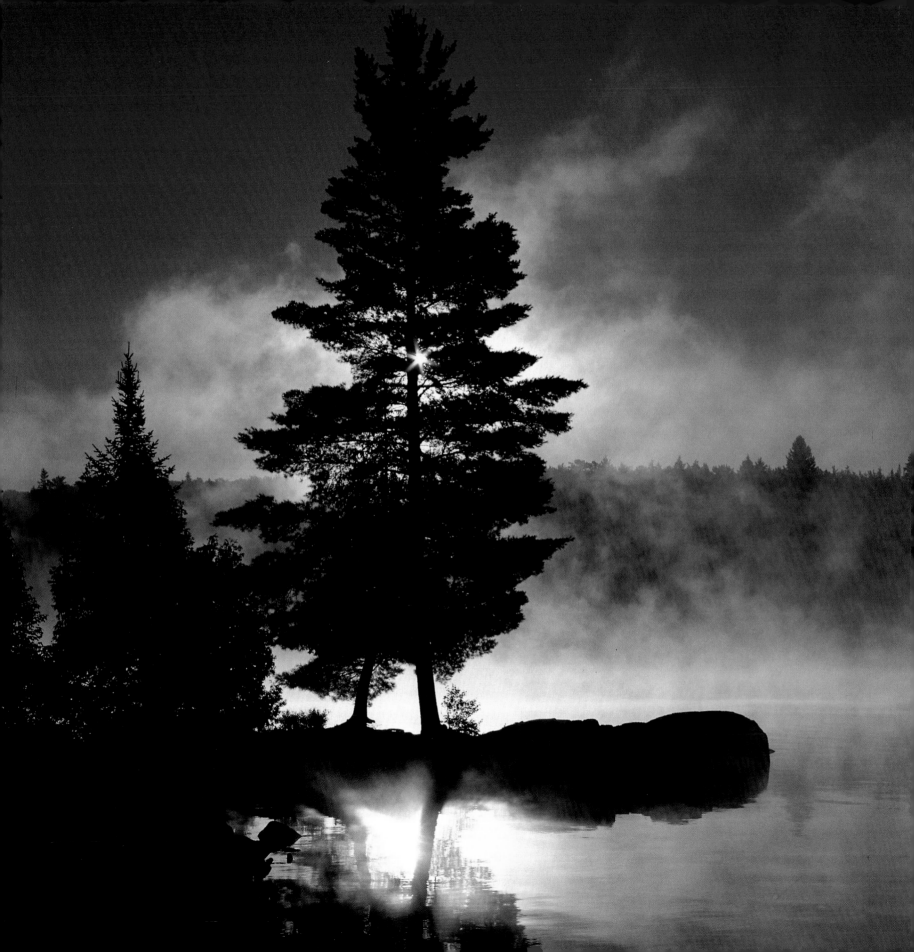

ALGONQUIN SEASONS

A NATURAL HISTORY OF ALGONQUIN PARK

MICHAEL W. P. RUNTZ

FOREWORD BY ROBERT BATEMAN

Stoddart

First published in 1992 by

Stoddart Publishing Co. Limited

34 Lesmill Road

Toronto, Canada

M3B 2T6

Canadian Cataloguing in Publication Data
Runtz, Michael W.P.

 Algonquin seasons

ISBN 0-7737-2566-0

1. Biology – Ontario – Algonquin Provincial Park –
Pictorial works. 2. Biology – Ontario – Algonquin
Provincial Park. 3. Algonquin Provincial Park
(Ont.) – Pictorial works. 4. Algonquin Provincial
Park (Ont.). I. Title.

FC3065.A4R85 1992 574.9713'147 C92-093274-6
F1059.A4R85 1992

COPY EDITING: Heather Lang-Runtz

BOOK DESIGN: Brant Cowie/ArtPlus Limited

PAGE MAKEUP: ArtPlus Limited

Printed and bound in Hong Kong

To all the naturalists — past, present and future — whose hearts and

imaginations have been or will be captured by wild places like

Algonquin Provincial Park

Contents

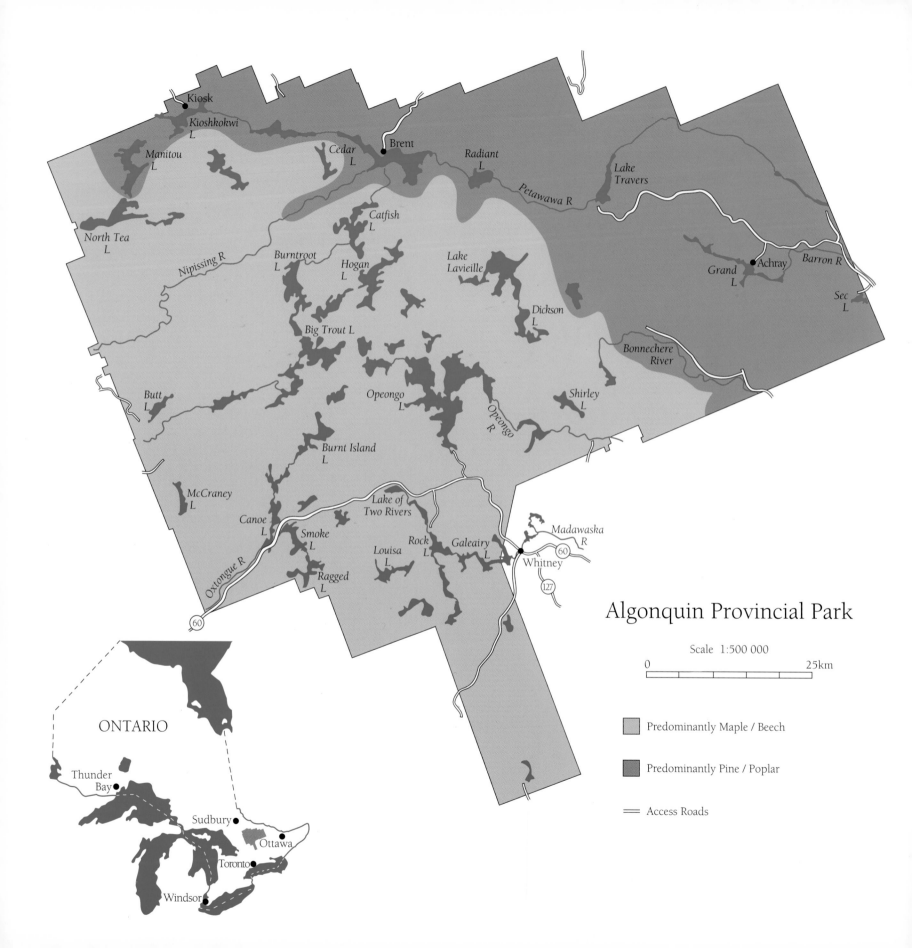

Kiosk

Kioshkokwi
L

Manitou
L

Cedar
L

Brent

Radiant
L

Lake
Travers

Petawawa R

North Tea
L

Catfish
L

Nipissing R

Burntroot
L

Hogan
L

Lake
Lavieille

Grand
L

Achray

Barron R

Sec
L

Dickson
L

Big Trout L

Butt
L

Opeongo
L

Opeongo
R

Shirley
L

Bonnechere
River

Burnt Island
L

McCraney
L

Lake of
Two Rivers

Canoe
L

Smoke
L

Louisa
L

Rock
L

Galeairy
L

Madawaska
R

60

Whitney

Oxtongue R

Ragged
L

127

60

Algonquin Provincial Park

Scale 1:500 000

0 25km

ONTARIO

Thunder
Bay

Sudbury

Ottawa

Toronto

Windsor

Predominantly Maple / Beech

Predominantly Pine / Poplar

Access Roads

Foreword

FROM MY EARLY CHILDHOOD days, Algonquin Park was to me a mythical place . . . almost at the edge of the world. I grew up wandering the lush, benign and accessible ravines of the Toronto area. And from the age of eight, my summers were spent in Haliburton County — cottage country just south of Algonquin Park. It, too, was accessible and benign, with its pioneer farms, wandering roads and chains of lakes. Yet although it was on the Canadian Shield and had vast forests, it was not Algonquin Park. "The Park," as we called it, was back of beyond, with forests of "bob-tailed" black spruce, rugged shorelines, wild, twisted rivers, orchid bogs and moose swamps. Occasionally, one of the great northern birds would drift our way: a Common Raven or Osprey or the smaller "whiskey jacks," three-toed

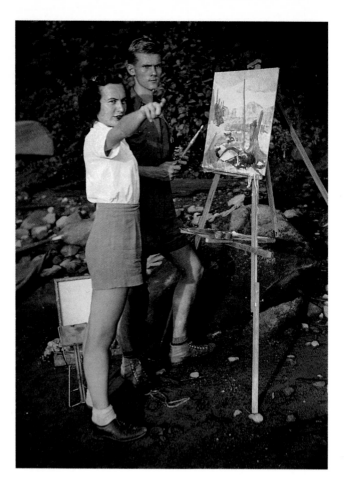

Many famous Canadians have passed through Algonquin. Robert Bateman, seen with Barbara Caldwell gesturing beside him, worked at the Wildlife Research Station as a teenager. Here, he paints a shoreline scene at Sasajewun Lake, on which the station is situated.

(Donald A. Smith)

woodpeckers or Boreal Chickadees. Even these snippets of observations transported me to the fabulous Canadian wilderness I had only read about in the books of Seton, Roberts, Grey Owl and Hemming. Those were Second World War days. Gas was rationed, and Dad dropped us off and left us carless until he came up for his holiday. To actually visit the Park was beyond my dreams.

Then in 1947 an unbelievable piece of luck changed my life. I was offered the job of chore boy (Joe boy) at the wildlife research station in Algonquin Park. I dug garbage pits, dried dishes, repaired the potholes in the road. But because they knew I was a naturalist, I was allowed to run the mouse trapline, skin and stuff the specimens, do the bird and deer censuses (counting droppings) and plot plant habitat. I was fortunate enough to do this for three summers. I say that this experience changed my life because the wildlife biologist graduate students became role models for me. They were a combination new to my social sense — rugged outdoorsmen, who knew how to sharpen an axe and paddle a canoe, and yet cultured types, who enjoyed classical music, folk songs and had daily literature readings after lunch. The other important aspect was, of course, their scientific thinking. The weekly progress reports and peer critiques under the spruce trees were a lesson in logic and thought.

One of my wilderness highlights from those days was the evening I paddled my canoe to the north of the lake (the north continued to have a mythical quality). I settled on a large rock with my oil paints. The rock was like an island among the lily pads, with open water to my front. I was concentrating on my paintings when I heard a snort. I looked up and saw only a ripple. I heard another snort, but saw nothing. Then, only ten feet in front of me up popped an otter's head, then another and another, until there were five in a semi-circle, staring and

snorting with evident indignation towards this intruder into their world. On another occasion, I lingered at the north end until after dark. I am always very quiet when I am alone in the wilderness. I pride myself that my paddle doesn't even make a drip or a gurgle. At that moment, a melodious moaning wolf call came from the dark forests to the north — only one, but I can feel the hair rise on the back of my neck even now as I think of it.

Of course, in those years I became a Group of Seven "groupie." I studied the work of Tom Thomson and the others, and became fascinated with their lifestyle and ideals. Every minute I had to myself during daylight I would paddle or hike to a suitable spot and do an oil sketch. I made it a point of principle never to go back to the painting once I left the field. The feel of the wind in my hair, the rock or moss on my bottom and the sounds of nature in my ears were essential to the process; the essence of the moment was not transferable to the studio. This set my painting pattern for more than the next decade.

At the age of twenty-one, I was again lucky enough to get a job at the fisheries research station at Lake Opeongo. I continued my Algonquin pattern of the earlier years at Lake Sasajewun.

Since then I have been back for many visits to lead groups of naturalists or students on canoe trips. I have helped with the wolf howling programs and have enjoyed the Park in all seasons.

Algonquin Park has been important to countless people through the years. Its influence goes far beyond the preservation of some plants and animals and square miles. In the Canadian psyche it has established a spiritual link with the great Canadian wilderness. The north is a state of mind worth cherishing and protecting.

ROBERT BATEMAN

Acknowledgments

I GRATEFULLY acknowledge the many people who offered assistance during the formation of this book. Many members of the Ontario Ministry of Natural Resources, in particular, Algonquin Park Superintendent Ernie Martelle, Chief Park Naturalist Dan Strickland and Park Naturalist Ron Tozer, provided logistical support. I also extend thanks to all those individuals — unfortunately too many to name — who over the years either provided enjoyable company during excursions into the Park or who offered technical advice.

In addition, special thanks to the abovementioned Dan Strickland and Ron Tozer for their encouragement and critical reviews of the text. I also thank John E. Marcil for producing the excellent map of Algonquin and Robert Bateman for contributing a superb foreword.

And an unreserved thank you to my wife, Heather, and son, Harrison, for selflessly permitting me to spend most of my time in my second home, Algonquin Provincial Park.

I am indebted to the following organizations for their technical support:

ALGONQUIN OUTFITTERS

Canon

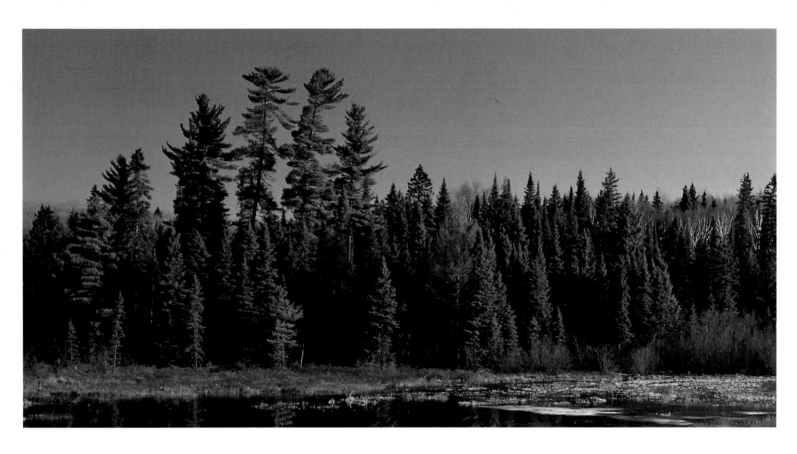
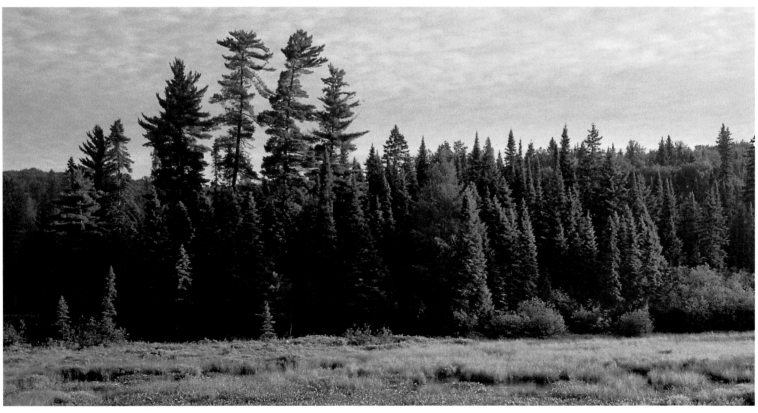

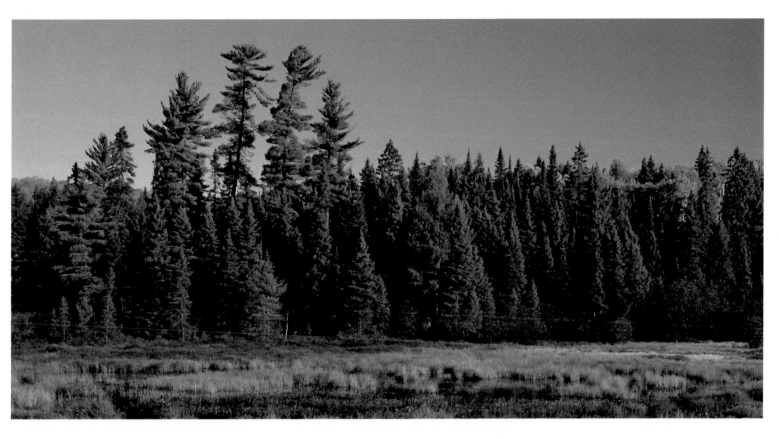

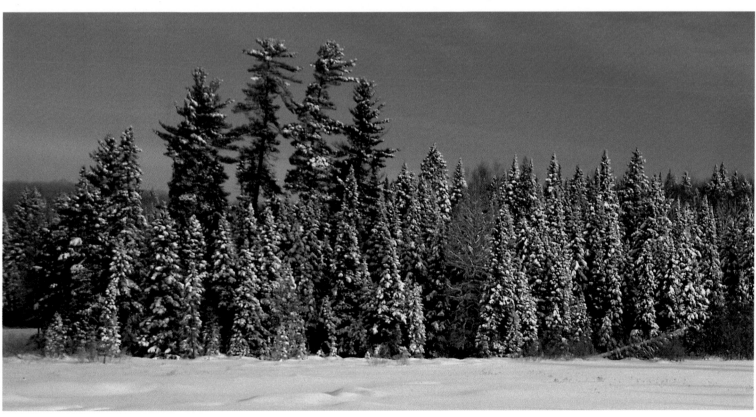

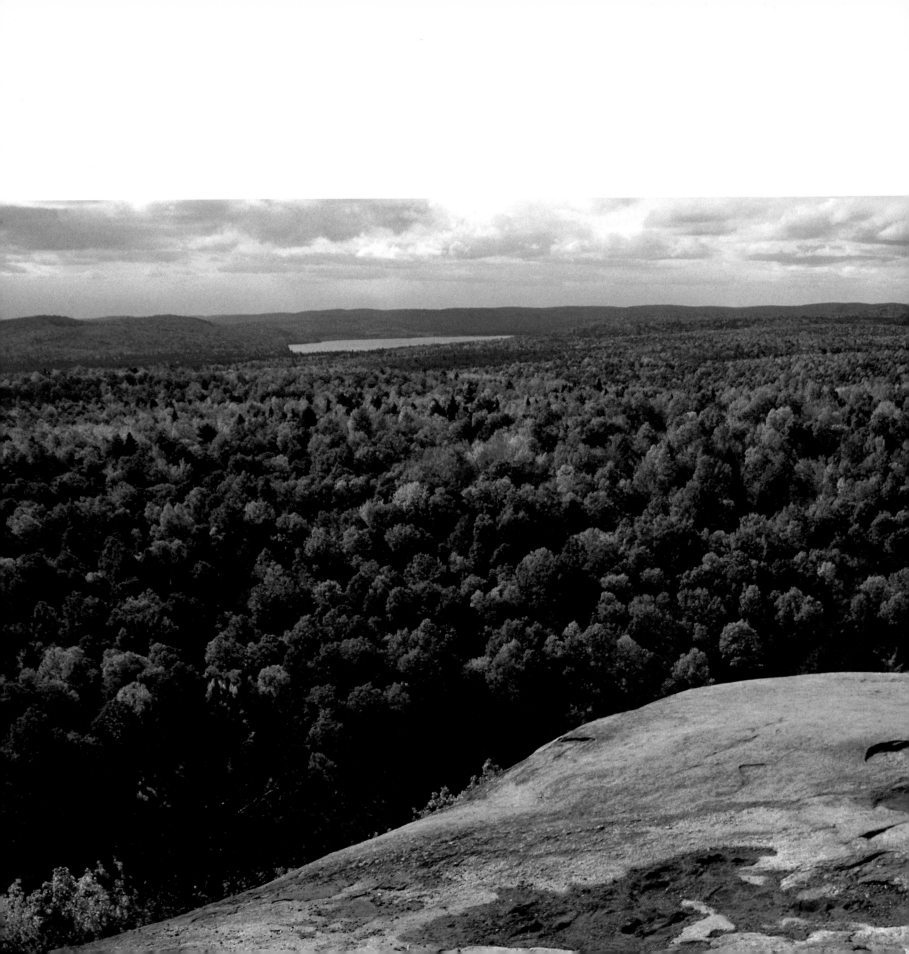

Coliseum of Life

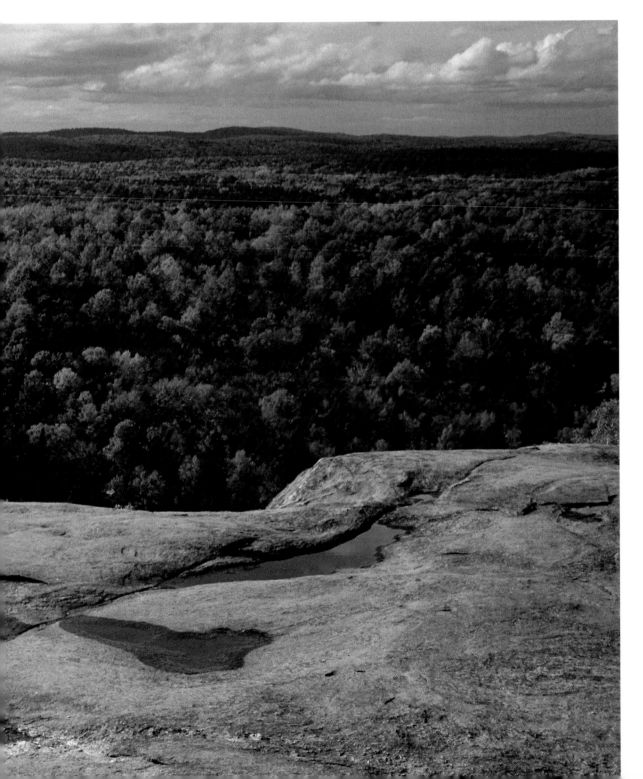

The western side of the Park is an endless sea of rolling hills covered in hardwood forest.

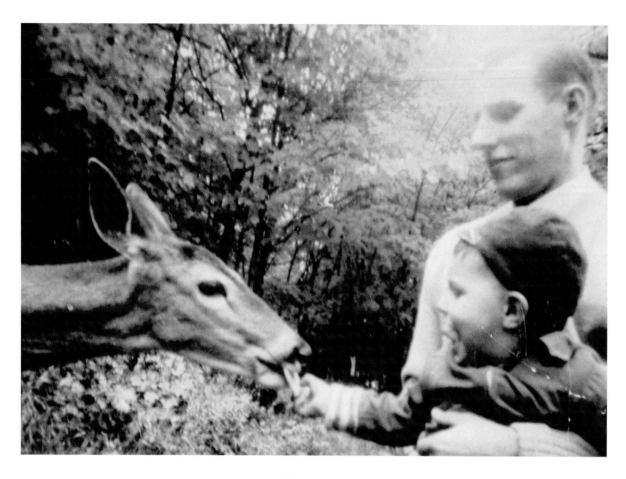

Held by his father, the author (the smallest of the three) encounters his first white-tailed deer in Algonquin Park. Due to the aging of the Park's forests, deer have declined in numbers from the early 1900s.

(JUNE DONNA RUNTZ)

I WAS A MERE THREE YEARS OF AGE when my parents first took me to Algonquin Provincial Park. We came, as did many in those years, to see and feed the numerous white-tailed deer that boldly frequented the highway's edges. I will forever cherish the memories I have of those gigantic (and at times terrifying) beasts tugging salted crackers from my hands. Although white-tailed deer are less commonly seen in Algonquin now than in the 1950s, chance encounters with these and other wild animals continue to furnish lifelong memories for the thousands who visit the Park each year.

Algonquin has long been renowned for its wildlife. The area was officially declared a Park in 1893, partly to provide a safe haven for fur-bearing mammals, thereby allowing their depleted numbers to replen-

ish. Algonquin Park is one of the finest wildlife-viewing areas in North America, arguably even in the world. The abundance and accessibility of species that represent wilderness — animals such as Common Loons, beavers, moose, black bears and timber wolves — are particularly astounding when one considers that the Park is only three hours from major population centers such as Toronto and Ottawa.

Equally impressive is the diversity of life that Algonquin supports. More than forty varieties of mammals, almost two hundred and sixty types of birds and about one thousand species of plants have been recorded within the three thousand square miles (seven thousand, six hundred square kilometers) that constitute this great Park. But perhaps more striking than the variety is the amazing mixture of flora and fauna. Black spruce, moose and Spruce Grouse, typical inhabitants of northern regions, can be found in close proximity to more southern elements such as sugar maples, white-tailed deer and Scarlet Tanagers. Part of this blend is due to Algonquin's location in a transition zone between northern coniferous and southern hardwood forests. But what gives Algonquin its varied habitats, and ultimately its unique character, is largely its diverse terrain.

The western side of the Park is characterized by rolling upland hills reaching elevations of one thousand, nine hundred feet (six hundred and thirty meters). These are much higher than the surrounding land, resulting in a dome effect. As the last glaciers retreated a mere ten thousand years ago, a thin layer of sand, gravel and boulders was left behind on these rounded hills. The hills currently support a hardwood forest in which sugar maples dominate the beeches, yellow birches and other components. On cooler slopes, hemlocks form dark stands. During the annual autumn extravaganza, these western uplands are transformed into resplendent mosaics of oranges, golds, reds and greens. The hilly terrain is punctuated by a tortuous network of sluggish streams, tranquil ponds and innumerable lakes. From these quiet waters emanate the humble beginnings of such major rivers as the

Amable du Fond, Bonnechere, Madawaska, Oxtongue and Petawawa. Along the cool, moist margins of these wetlands, northern bog and coniferous forest elements, such as labrador tea, black spruce, white cedar and balsam fir, thrive.

The eastern regions of Algonquin possess a completely different flavor. This side of the Park receives less precipitation than the more elevated western reaches. The predominant winds arrive from the west, and as they pass over the western uplands, much of their moisture is dropped. Extensive beds of sand, deposited by glacial waters, cover a large portion of this side of the Park. These drier and sandier conditions favor the growth of forests of red, white and, in certain areas, jack pines. Perforating the darkness of these pines, the pale trunks of poplars loom bright. The vibrant fall colors of the maples that dominate the western uplands are replaced by the ocherous hues of the red oaks that cover the eastern hilltops. And here, in the east, the face of the Park is more dramatic, with rugged rocky cliffs lining wild rivers, which churn and thrash through rapids and plunge down thundering falls.

However, beneath this beauty lies a changeable demeanor. Much of the time Algonquin displays a benign and complacent visage, and for many organisms life is comparatively easy. At other times, a frugal, almost malevolent disposition tests the fortitude of all living things. The most severe of challenges occurs during the frigid winter months, when temperatures plummet below minus forty degrees and an impeding snow cover frequently exceeds a depth of three feet (one meter). These conditions tax the stamina of all that remain active, and the ill-prepared perish.

Even in the more forgiving seasons, restrictions are imposed on both the floral and faunal inhabitants of the Park. The enduring precambrian rock that underlies Algonquin and exposes its distorted face in every lakeside cliff releases nutrients slowly. As a result, the soils and waters are relatively nutrient poor and moderately acidic. Only plants adapted to these demanding conditions survive. The plants, the basis of the

entire food chain, ultimately dictate the types of animals that will live here. Thus, all components of the complete web of life are in some fashion controlled by this ageless bedrock of the Canadian Shield.

The cold, clear waters of Algonquin, while not suitable for many organisms found in richer and warmer waters farther south, are nevertheless ideal for some types of fish, most notably brook and lake trout, and these abound through much of the Park. The exploiters of fish, from saw-billed mergansers to the undisputed masters of the water, the loons and otters, also thrive in the incomparable network of streams, rivers and lakes.

Although numerous access roads allow one to penetrate the Park's perimeter at various points, only one public road, Highway 60, actually crosses Algonquin, in the southwest portion, with thirty-seven miles (fifty-six kilometers) of pavement separating the east from the west boundary. Along this corridor are located the majority of the Park's public campgrounds, superb interpretive trails and facilities. But one cannot drive from here into the more distant reaches of the Park.

To explore the Park's vast interior, one must resort to the ways of the earliest human inhabitants, the Algonkin and Huron Indians. As did these natives, who once camped along the present Park's shores and fished its tranquil waters, one must access remote regions by foot or canoe. And although two well-developed hiking trails allow one to travel partway into the heart of Algonquin, the one thousand miles (one thousand six hundred kilometers) of established canoe routes provide the greatest exposure to its soul. One can travel for days on end, setting up camp on pine-shrouded islands and wind-blown points and never visiting the same body of water or campsite twice. Here, in this maze of water and portages, one can escape the confusion and complexity of everyday life, swallowed up by the immensity of Algonquin and intimately exposed to its secrets and moods.

Algonquin's incredible size can perhaps best be appreciated from atop a glacier-scoured precambrian cliff. As you rest upon the unyield-

ing rock and survey the seemingly endless waves of rolling hills, you are overwhelmed not only by the freedom of unrestrained space but also by a sense of the region's agelessness and permanence. These feelings are not unfounded. Billions of years have passed since this rugged bedrock was formed, and ten millennia have transpired since the omnipotent mass of grinding glacial ice last scoured the landscape. Ancient waterways vanished while new ones were born. Since that time of cold and lifelessness, generations of forests have quietly come and gone. The face of Algonquin has been radically made over many times, but for the most part the changes have been gradual, unobserved by human eyes. Only scattered and often obscure clues reveal the magnitude and consequence of past forces.

Not all changes have been so remote in time. In less than two centuries man not only has altered the appearance and composition of Algonquin's forests but also has affected the flow and levels of waters running from the Park. With axe and saw, trees were eagerly harvested, and the virgin white pines that once towered over the maples and beeches of the western highlands can now be revered in only two isolated sites. The loss of virgin trees and the opening of the primeval forest may have negatively affected such animals as woodland caribou, but the appearance of a younger, more open forest has benefited others, particularly white-tailed deer and beaver.

The exploitation of the forest continues. However, logging is now selective in nature and localized in operation. While arguably not conducive to a true wilderness setting, this disturbance of the forest does not destroy the visitor's perception of a wild and beautiful place.

Within this complex framework of rock and water, of bog and forest, modified by past events of enormous magnitude and by the manipulation of modern man, multitudes of living organisms survive and interact. Algonquin Park is a gigantic living stage upon which not one but countless life-and-death dramas are performed daily. Some are of a dramatic scale, such as a pack of timber wolves taking down an

aging and ailing tick-infested moose. Others are of a smaller, though equally dynamic, dimension: a crab spider, perfectly camouflaged on a fireweed flower, suddenly snares and dispatches with lightning speed an unsuspecting hover fly lured by the prospect of nectar; below the water's surface, a tiny water flea brushes against the hair trigger of a bladderwort sac, which suddenly opens, sucking the unfortunate victim into its deadly grasp.

No matter through which habitat your meanderings take you, regardless of the season of your visit, the players that make Algonquin their home are holding stage. For visitors who take the time to look, the rewards are tremendous. A silent pass by canoe along a boggy shoreline as the day begins to break; a search on hands and knees into the hidden flowers of a bunchberry; a quiet stroll around a beaver pond as the evening air fills with song — each will be sure to provide you with novel and fascinating insights into the true heart and soul of Algonquin Provincial Park. And all through the year new adventures await discovery, for as varied as the landscape are the moods and complexities of each of the extraordinary Algonquin seasons.

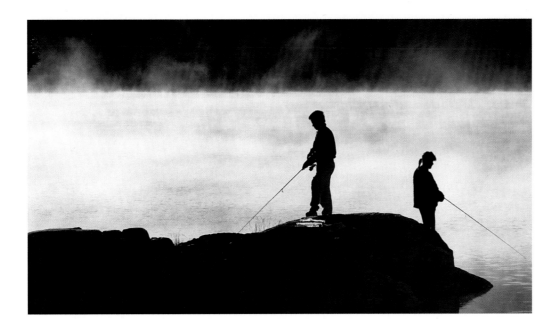

The same fish that are food for loons provide memorable angling opportunities for many visitors.

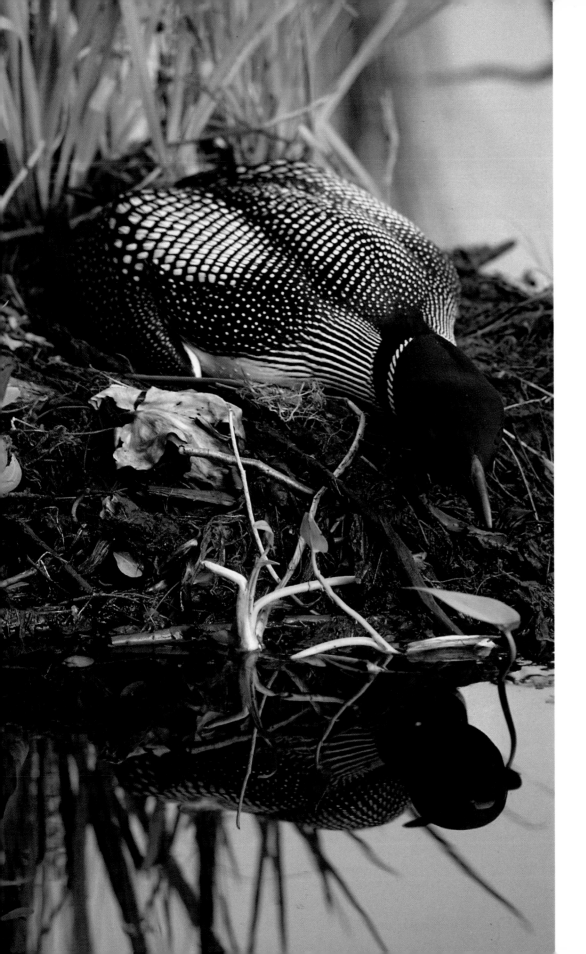

The abundance of water provides ideal feeding and nesting habitats for a variety of water birds, particularly loons.

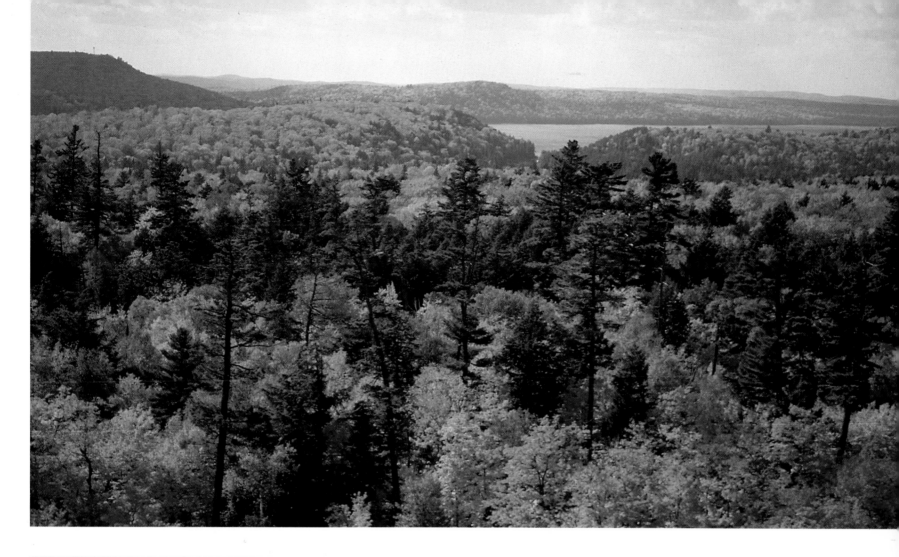

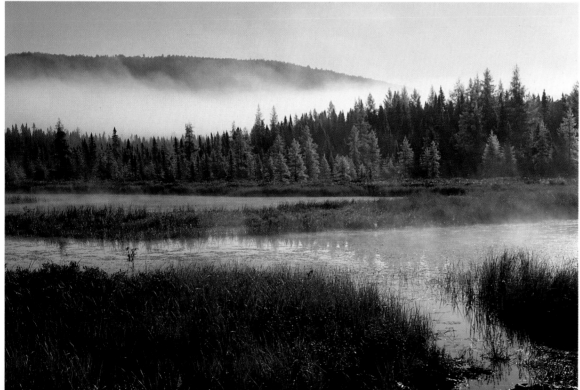

The original virgin white pines once found scattered all through the western uplands now can be viewed only at two isolated sites. Here, the Crow River pines tower above the blazing hardwoods.

Algonquin's richness of life is due to an amazing variety of habitats, including northern bogs that fringe the edges of slow-moving waters.

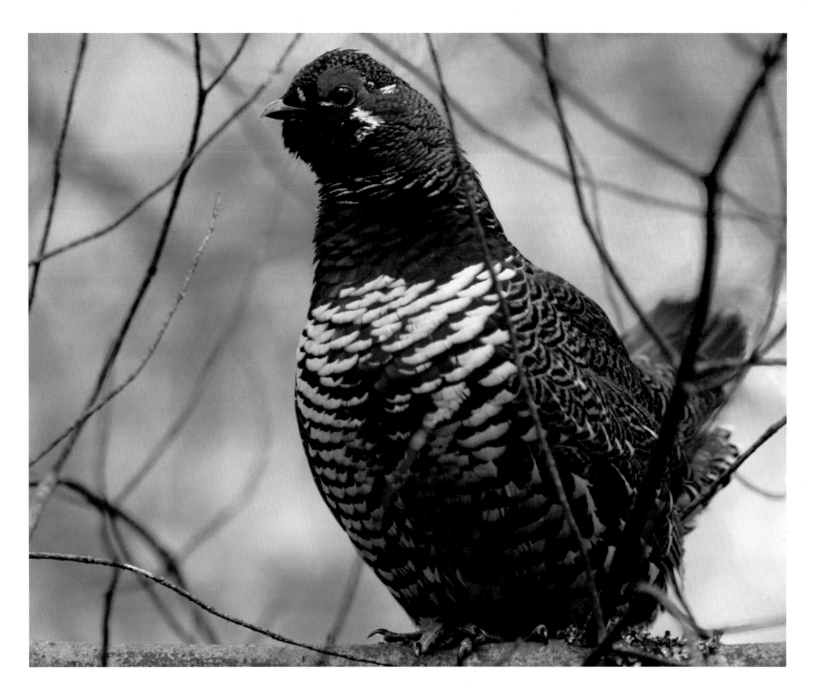

Algonquin is home to many creatures that frequent boreal regions. For some, such as the Spruce Grouse, the Park is the southern limit to their otherwise more northerly range.

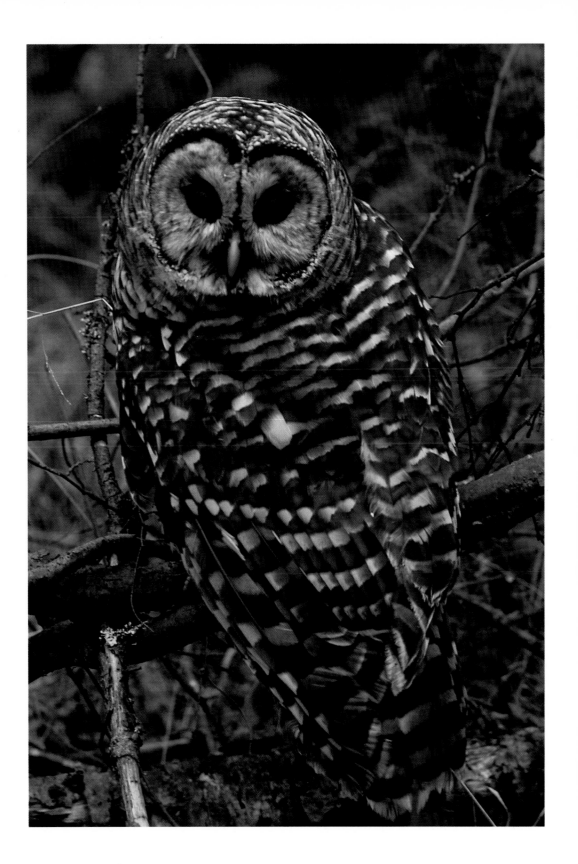

The only owl that commonly nests in the western uplands, Barred Owls frequently startle campers with their booming calls and eerie cackles.

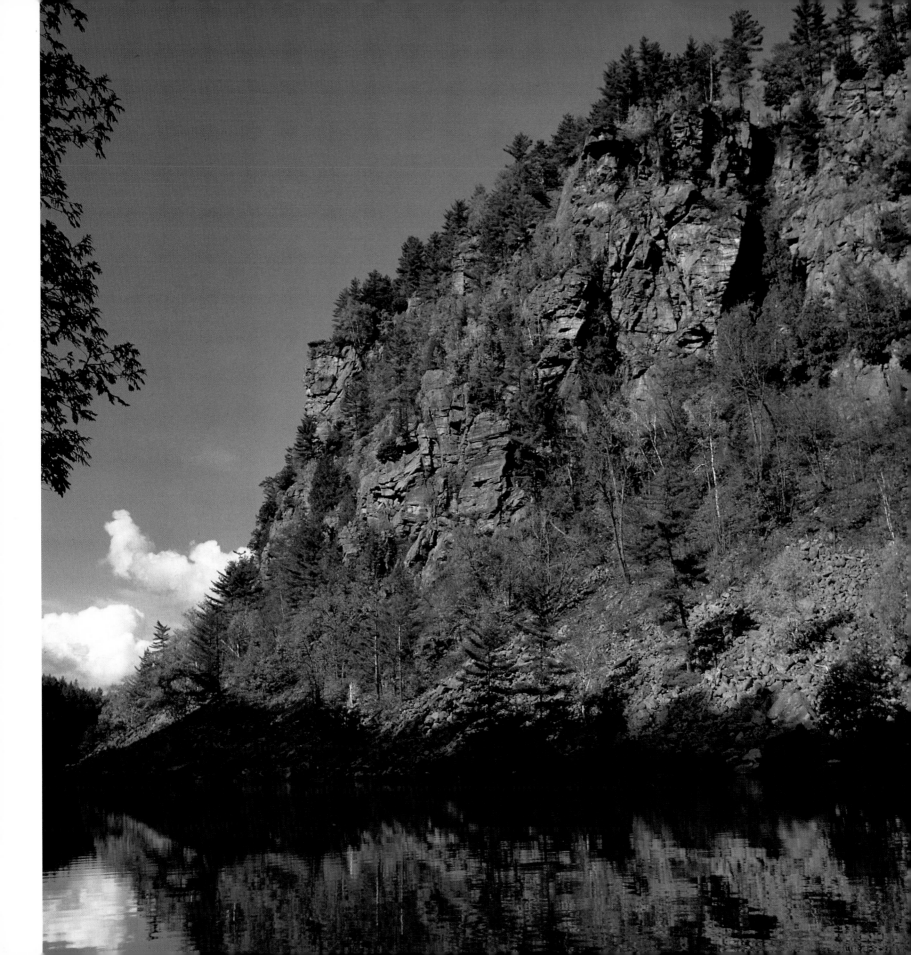

Spectacular cliffs, including the breathtaking Barron Canyon, border rivers and lakes in the eastern regions.

With its varied forests and complex maze of waterways, Algonquin offers unlimited wilderness experiences.

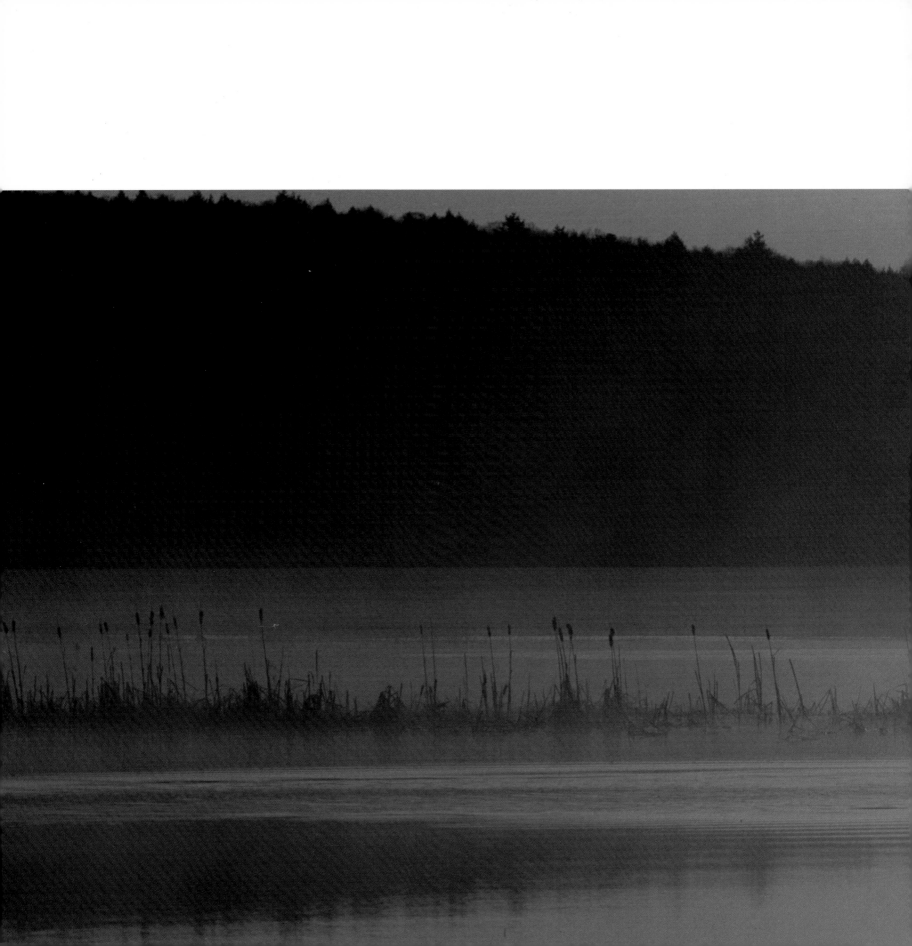

CHAPTER ONE

Season of Awakening

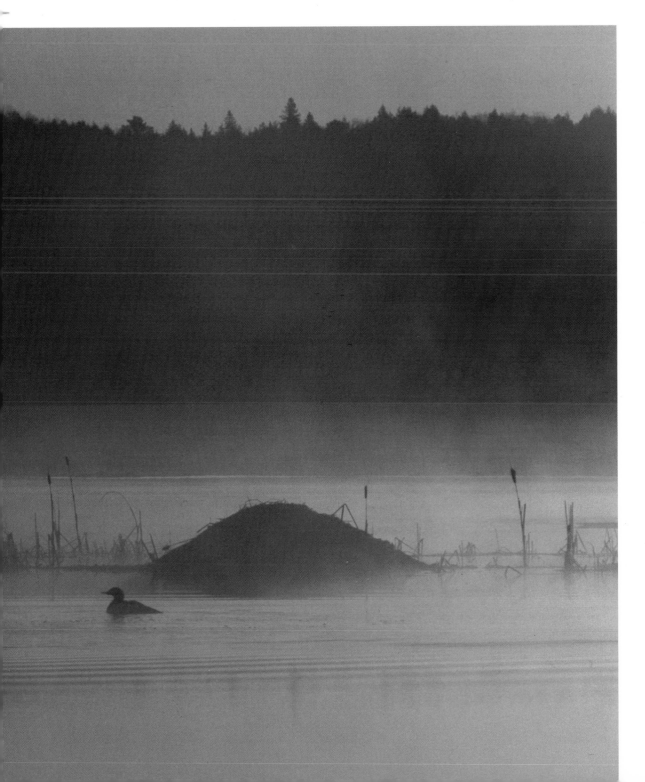

As the ice retreats, a flood of life invades the liberated waters. Hardy ducks, such as this male Common Merganser, are the first to appear with the arrival of spring.

Under the penetrating stare of the spring sun, winter snows dissipate and streams swell. While some persist throughout the year, many of these rivulets will vanish in the drier months ahead. By early April the gurgling and babbling of these unshackled waterways are background music to the sweet rolling trills of newly arrived Winter Wrens.

ALTHOUGH EACH ALGONQUIN SEASON possesses a profoundly distinct ambience and vitality, the boundaries between them are ill-defined. The subtle arrival of each season merges casually with the lingering departure of its predecessor. Thus, the springtime transition from a land of frozen silence to a world of intoxicating bustle is, at first, gradual and reluctant. But as the days slowly lengthen and warm, stirrings of once-dormant lifeforms and the arousal of hidden behaviors foretell winter's demise.

Long before the bogs are freed from their fetters of ice and the boreal trees echo with the songs of returning warblers, Gray Jays glide purposefully through the cold northern haunts. With silent devotion, they deliver nesting material to the snow-laden boughs of a spruce or fir.

These gentle birds frequently are on their eggs by late March, braving the chill and heavy snows that may yet fall. As they silently brood on their bulky nests aloft, spectacular displays are performed below.

With a crimson comb inflated over each eye, a male Spruce Grouse struts proudly through the shafts of light that illuminate his snow-bound stage. His cocked tail swishes and stiffly fans open and closed, displaying each half with each step taken. With a burst of wings, he flutters noisily to an elevated perch, only to return just as loudly to the ground once more, vying for the favors of a discriminating hen.

Meanwhile, life slowly returns to the melting waterways. The swelling streams discard their coats of ice and lakes begrudgingly release their icy grip on surrounding shores, as waterfowl return to feed and mate. By the middle of April, pairs of Black, Ring-necked and Wood Ducks and Common and Hooded Mergansers can be found almost everywhere that open water prevails. As more water is exposed, loons return to stake old claims. Great Blue Herons stalk the shallows while Herring Gulls scream from overhead. Tree Swallows twitter over the edges of the receding ice where otters, indifferent to all the commotion, feast on crayfish captured from the cold depths.

The spell of the springtime sun restores life to Algonquin's forests, as well as to its waters. As the crystallized snows shrink and collapse, chipmunks emerge from their underground dens. South-facing slopes are the first to shed their snowy shawls, and all through the moldy mat of winter-flattened leaves, new life begins to unfold. Carpets of spring flowers burst open to embrace the life-giving light before the sun's warming rays are blocked by the unfurling tree leaves overhead. Everywhere the golden bells of trout-lilies, the purple haze of violets and the blush of red trilliums emblazon the forest floor. Resurrected from their winter comas, angle-winged butterflies dance among this masterpiece of color.

Tiny black bear cubs, born during their mother's winter sleep, now scamper behind her as she searches for fresh growth. On sun-

drenched slopes, piles of fresh diggings reveal the dens of foxes and wolves. Some of these excavations may be aborted experiments, but others will house new litters over the weeks that follow. Cow moose seek the water-bound confines of islands and peninsulas, safer sites on which to deliver their calves.

Spring is an awakening of all of the senses. As temperatures rise above the freezing mark, a near-deafening chorus greets the darkness of nightfall. Spring peepers and wood frogs, resurrected from a semi-frozen state, fill the air with their din. From nearby spruces a persistent "toot-toot-toot," barely perceptible above the clamor, advertises the presence of a tiny Northern Saw-whet Owl. Higher up from the hardwood slopes, the booming "Who-cooks-for-you, who-cooks-for-you-aaaawwlll" of a Barred Owl echoes through the night.

The sun burns with increasing intensity as April melts into May, banishing winter snows except from the coldest, darkest retreats. Daily, new voices harmonize through the Algonquin dome. The squeals of Yellow-bellied Sapsuckers permeate the woods, overlaying the dull thuds of drumming Ruffed Grouse. As May progresses, the swollen buds of trees burst open and the unfolding leaves race to capture the life-giving light. Insects swarm through the canopy, drawn by opening leaves and the aroma of elevated blooms. In turn, these attract waves of jewel-like birds, whose songs saturate the forests of May and June.

Although the rushing waters retain their heart-stopping chill, hordes of black flies rise from the surface, their tiny wings finally freed from their pupal prisons. They relentlessly seek out victims, aggressively cutting flesh to attain blood, which is used to nurture the eggs developing deep inside the minute flies' bodies.

Spring is a vibrant season, filled with the awakening of life from winter slumber and the return of creatures from southern retreats. As new generations arrive to exploit the impending bounty of summer, Algonquin once again resonates with life, the harshness of the past months seemingly forgotten.

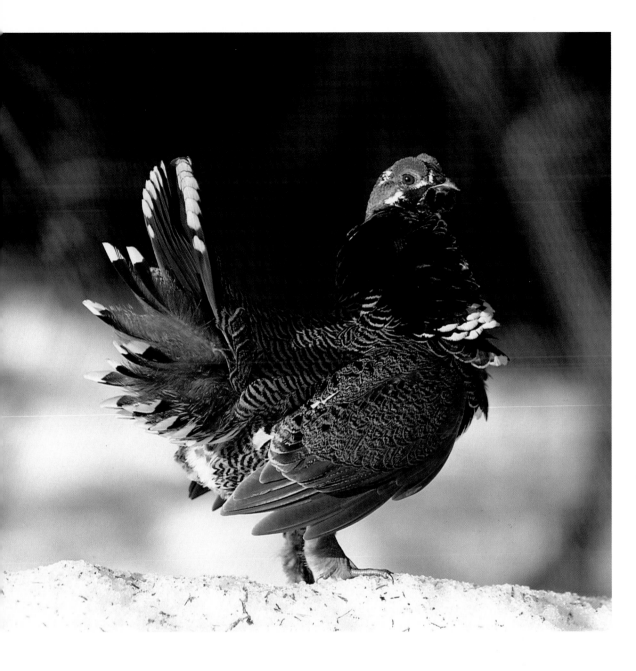

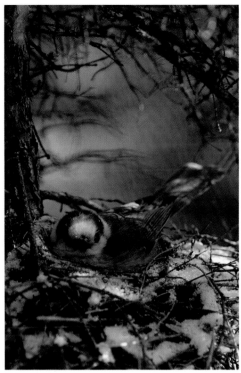

Braving late winter snowfalls, Gray Jays nest exceedingly early, in order to store sufficient food for the upcoming winter, still nine months away.

As the days lengthen, suppressed behaviors arise. Characteristically silent and inconspicuous, a male Spruce Grouse transforms itself into a theatrical show-off when courting a female. This tame northern grouse, unlike many birds that use vocalized song as their advertisement, employs noisy flutter-flights and the rustling of tail feathers as audible aids to impress a potential mate. Only in spring courtship is the red comb this inflamed, and the feathers so ruffled on the throat and under the tail.

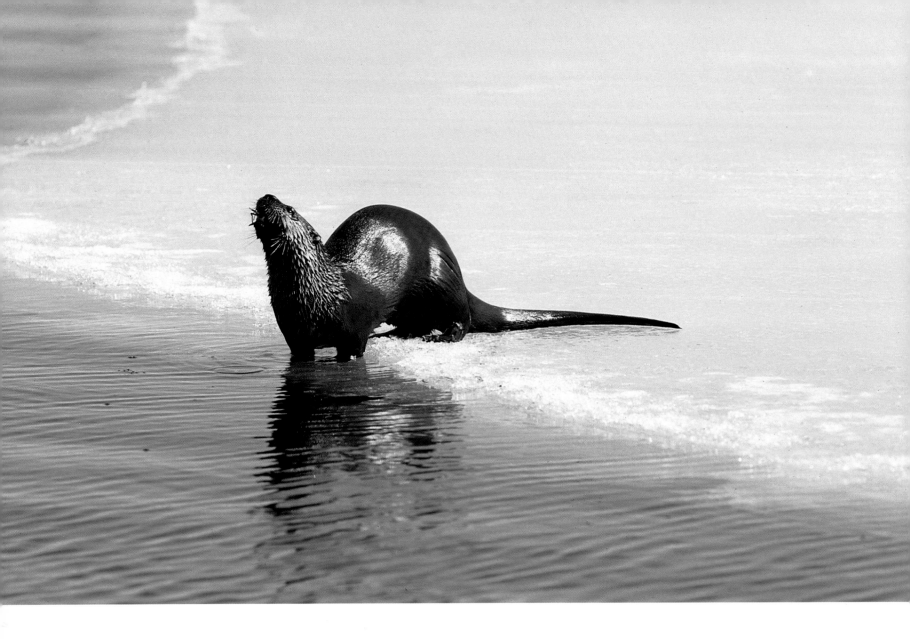

Masters of the water, river otters are as agile as the fish upon which they commonly feed. The edge of the receding ice provides a perfect dining table for a leisurely meal. Their diet is varied and ranges from aquatic insects, such as dragonfly nymphs, to speedy trout and crunchy crayfish.

The legs of a crayfish are seen here disappearing into the otter's powerful jaws. Long, coarse hairs near the mouth, known as vibrissae, are useful in detecting prey, such as crayfish, which frequently lie hidden on rocky or murky bottoms.

As quickly as the ice vanishes, *American Black Ducks appear on every open creek and pond. Unlike the mergansers, which thrive on fish, Black Ducks feast primarily on vegetable matter, especially the seeds of aquatic plants. At one time, this was the only dabbling or "puddle" duck that commonly bred in Algonquin. In recent years, however, Mallards have expanded their range into the Park and now not only co-inhabit some of the same ponds with Blacks but also readily interbreed with them.*

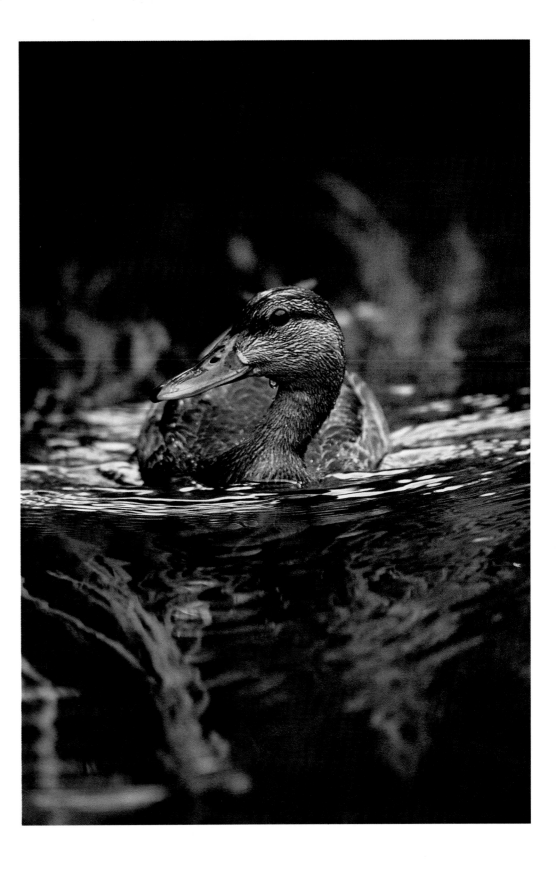

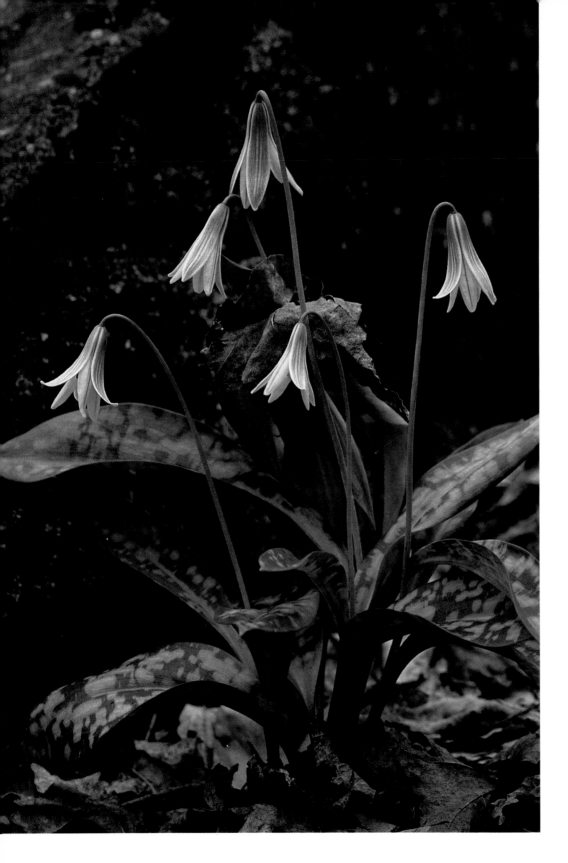

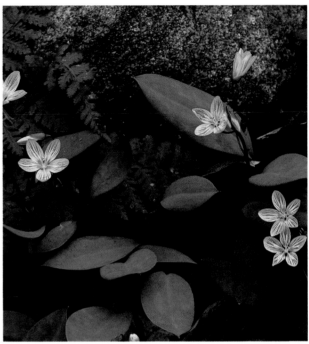

Between the end of April and the latter part of May, colorful carpets abound in the unrestricted light. Aptly named, spring beauties are one of the prolific blooms encountered during this season of visual splendor. As with the many other species that thrive at this time, they too will quickly vanish as the canopy of leaves overhead eventually shuts out the sun.

Trout-lilies often form dense colonies, for they not only reproduce by seeds but also spread vegetatively below the surface of the ground.

In its dying throes, winter can wreak havoc on flowers that venture out in search of unimpeded light. Both cold temperatures and late snowfalls can inhibit insect pollinators and injure plants, negating the benefits of flowering at this fickle time of year.

Mysteriously appearing on the one of the first mild days, a Compton tortoise-shell basks in the warming sun. Overwintering as adults under loose bark and in crevices, this and other types of angle-winged butterflies are the earliest to fly in the spring. Gracing the forest openings for only a brief time, they soon perish after laying their eggs on willow or birch. The next generation will fly in mid-summer, producing yet another set of descendants which will ultimately overwinter.

During the winter moose are sodium deprived as a result of their diet of conifer needles and twigs. Sodium chloride, better known as road salt, is employed to combat highway snow and ends up ploughed and washed into the bordering ditches. In the spring, moose are easily viewed as they glean this essential mineral from the roadside mud and waters.

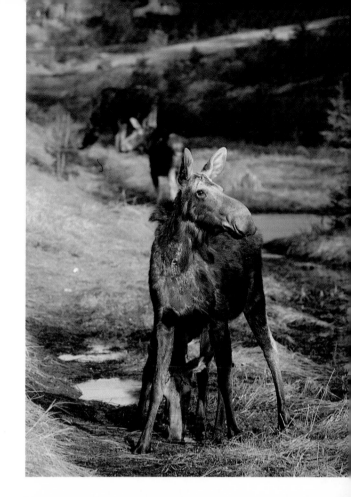

Young moose calves are usually found near water, for cows generally give birth on islands or peninsulas. These sites are normally safer for they harbor fewer bears, a major predator of calves.

The moose population in Algonquin rose quickly after the decline of the white-tailed deer, which carried a brain-worm fatal to moose. With plenty of resources available for a growing moose population, twins dominated in the births. During the mid- to late-1980s, however, moose became extremely common, numbering in the low thousands, and both food scarcity and other population pressures developed. As resources to support the cows dwindled, single calves began to dominate the spring scene.

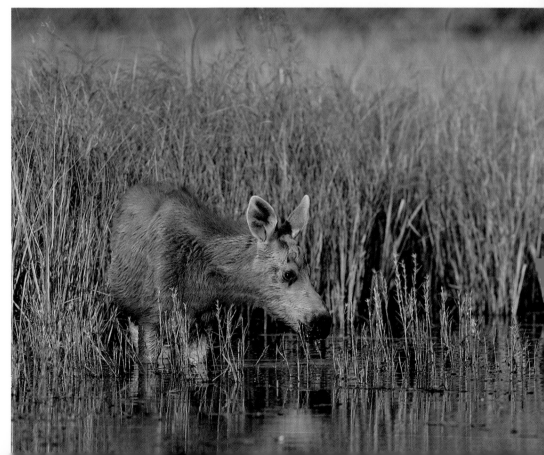

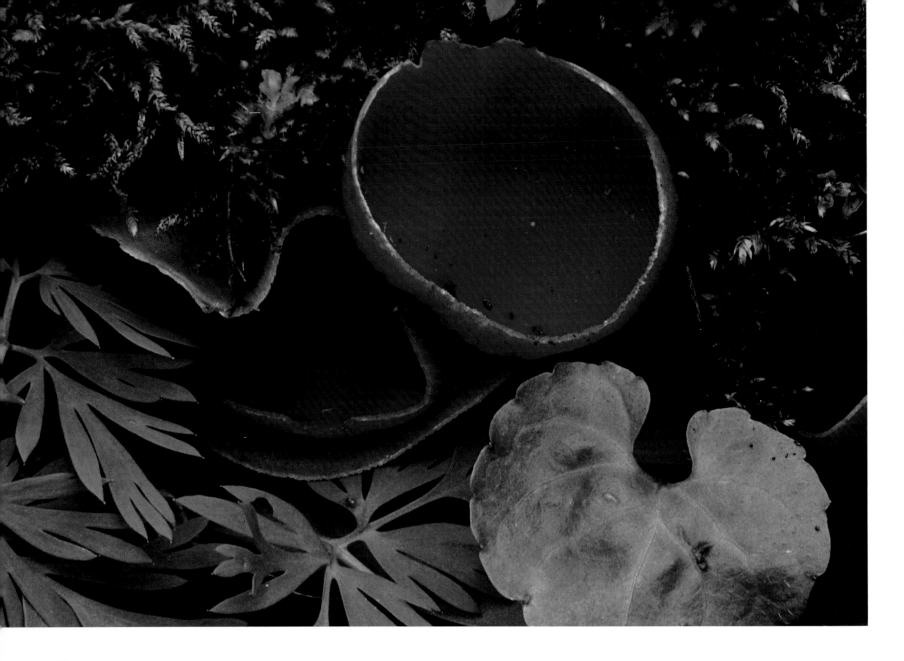

The liberated ground is not painted solely by sprays of spring wildflowers. Firmly attached to rotting wood beneath, the brilliant bowls of scarlet cup also grace the spring bouquets. Including a few that are deadly if eaten, many mushrooms are vitally important to the well-being of a forest. Breaking down nutrients locked in fallen wood, these fungi perform vital recycling and other essential roles.

As their name suggests, in addition to insect prey these woodpeckers feed on the sap of trees. These colorful woodpeckers frequently drill distinctive rows of holes in birches or hemlocks, and lap up the resulting sap flow. The tip of the specialized tongue contains hair-like structures that soak up the liquid through a capillary action.

Spring woods are alive with the querulous squeals of Yellow-bellied Sapsuckers. Males arrive about a week before the females, and not only their calls but also their distinctive drumming — a short roll followed by a half dozen slower taps — echo through the forests.

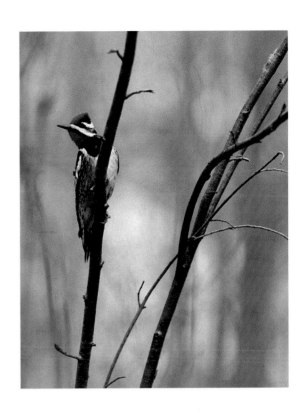

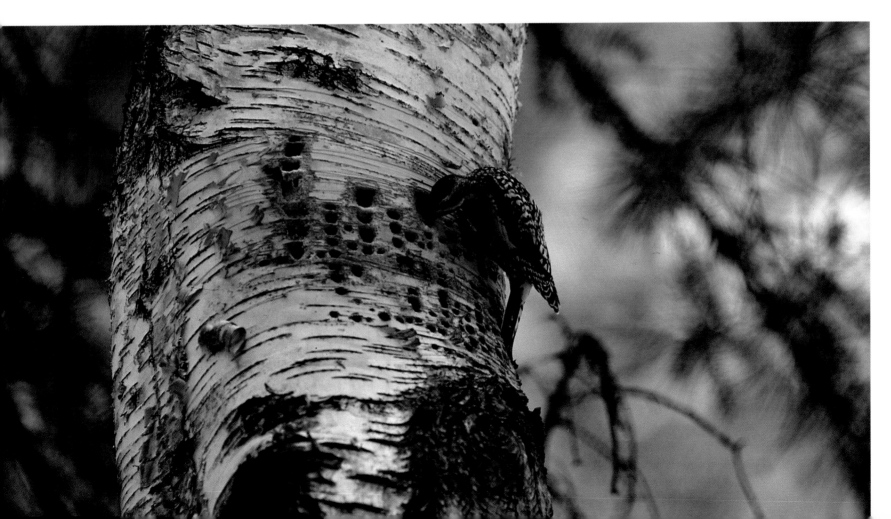

Pollen forms sticky bands of gold as it is discarded by the currents onto the rocky shore. Although it did not fulfill its biological role, the pollen cannot be deemed wasted. The organic debris is eagerly consumed by a number of organisms, including millipedes. This many-legged creature will soon vanish into a dark retreat, for it shuns the drying effects of the rising sun.

Resembling an abstract work of art, pine pollen coats the Barron River. Conifers, dependent on the wind for transport of pollen to female flowers abroad, release vast quantities into the spring air. Most of the pollen, settling wherever it is carried by the breeze, never reaches its intended target.

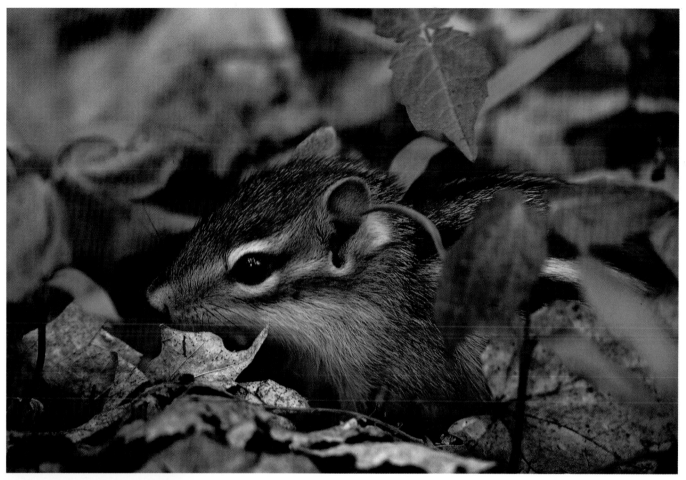

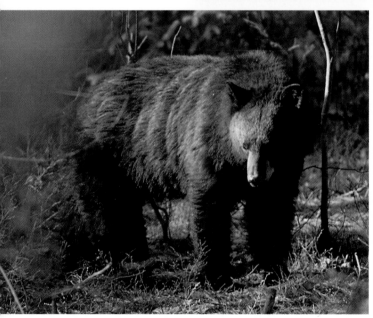

The warmth of this season soon arouses dormant animals from their winter retreats. Although eastern chipmunks are deemed to be hibernators, they are actually active beneath the ground surface part of the winter. Awakening every few days, they feed on underground stores in a special chamber and deposit body wastes in another.

Unlike chipmunks, bears lightly slumber through the winter. Upon awakening, they eagerly seek fresh green growth in forest openings.

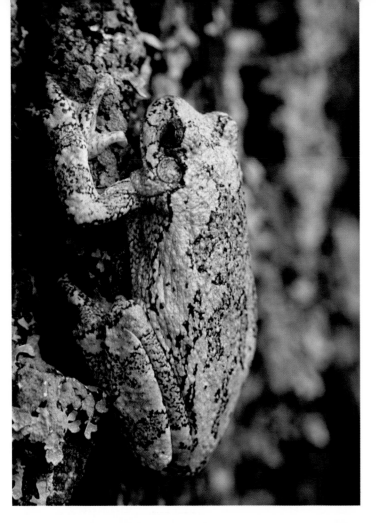

Many amphibians hide during daylight hours, waiting for nightfall before continuing their courtship songs. Gray tree frogs are cryptically patterned and can change the color of their skin to match their background.

Each spring brings a profusion of births, but few young survive to adulthood. Susceptible to disease, accidents and starvation, fox pups, as with most babies born in the wild, have little prospect of a long life.

Oblivious to the dangers that lie ahead, this fox pup, drying out after a heavy rain, seeks relief from an unwanted flea. The rest of its siblings, possibly numbering four or more, remain hidden in the den under the overhanging rocks.

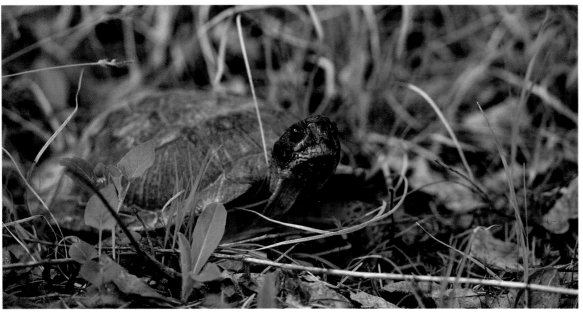

With late spring comes an exodus of female turtles from waterways to sandy sites. After depositing and covering their eggs in shallow holes, they once again return to their watery haunts. More terrestrial than any other of Algonquin's turtles, the seldom-encountered wood turtle spends much of its time lurking in moist alder thickets along waterways. These turtles are rare throughout their North American range, though diligent searches have turned up fair numbers in the Park's eastern reaches.

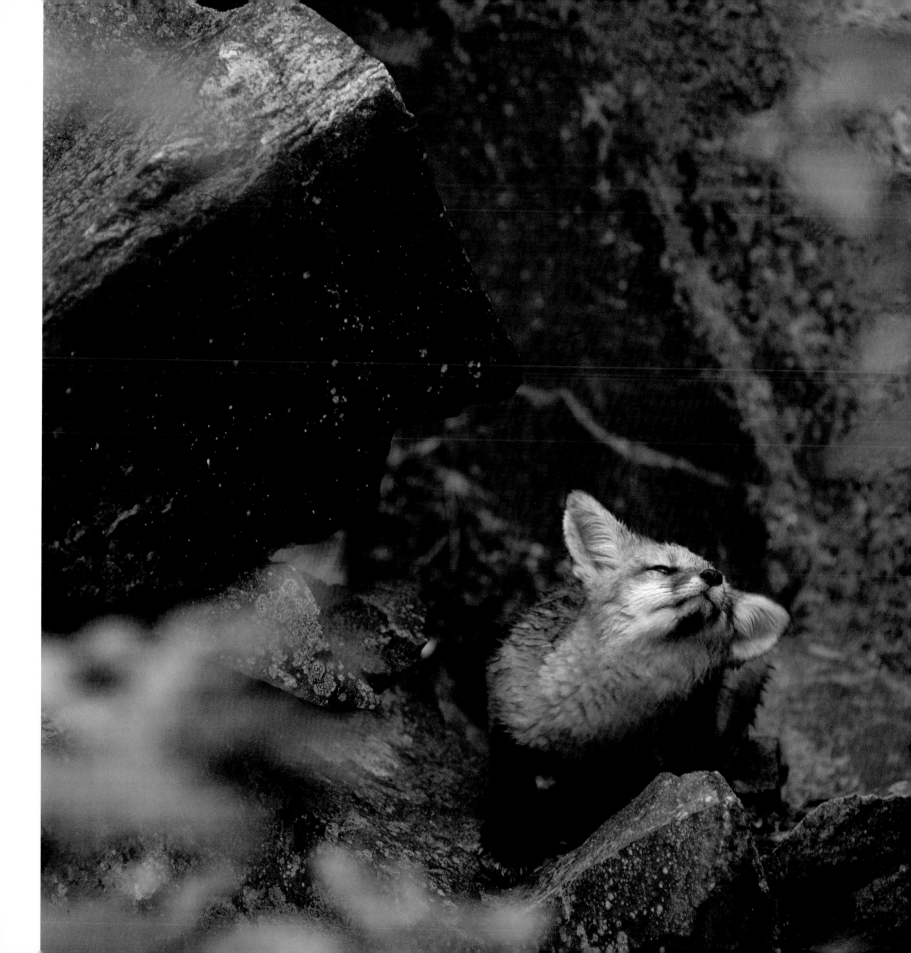

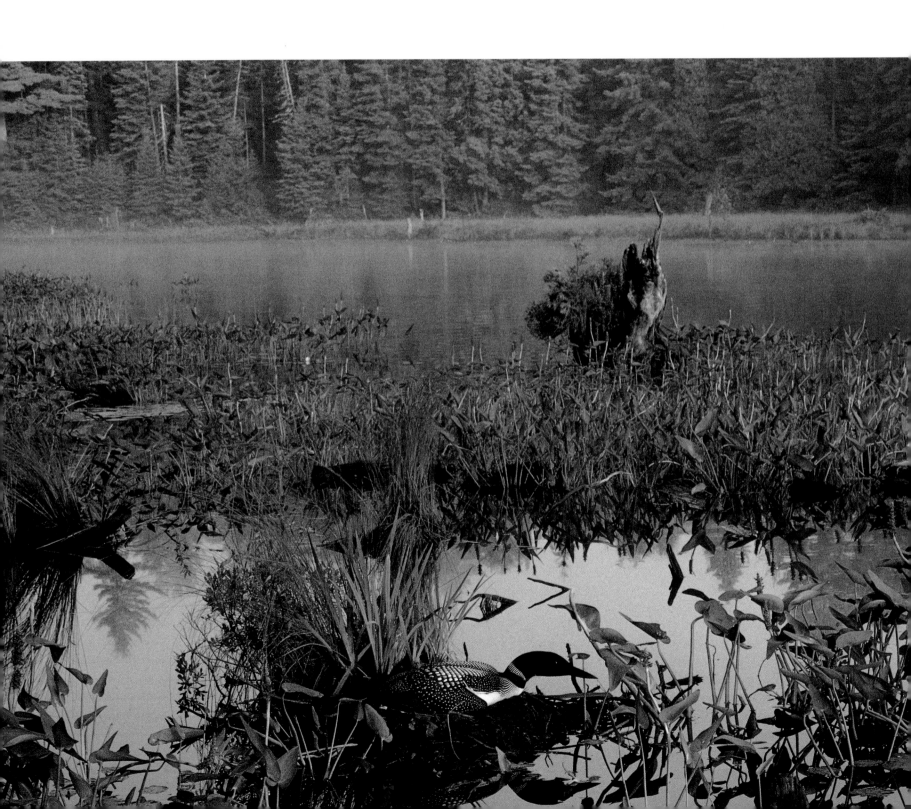

Season of Plenty

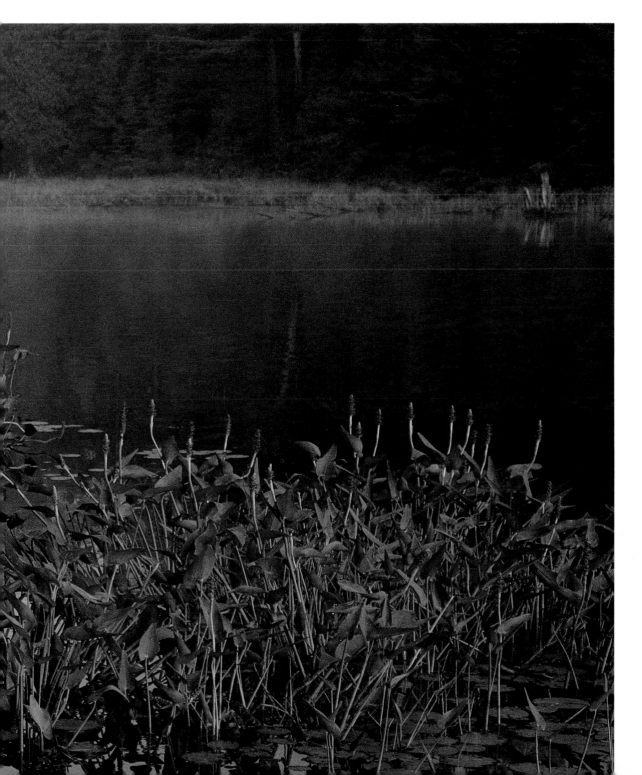

All through Algonquin, the relatively consistent heat and light of summer inspire a profusion of life. Shallow waters, choked by emergent armies of pickerelweed, provide nest sites for loons.

The whiteness of bunchberry flowers is really an illusion; the striking white parts are not petals but modified leaves called bracts. The tiny central flowers first arise as closed, ball-like objects with a pointed projection on one end. When this trip-wire is touched by an unsuspecting insect, the flower bursts open, showering the intruder with sticky pollen. Whatever lands on this bunchberry is in for another unexpected mishap, for a barely discernible crab spider waits with lethal patience.

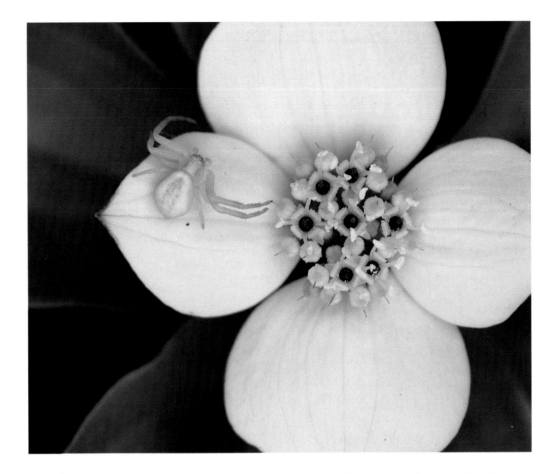

As THE FIRST RAYS OF LIGHT cut through the ashen haze, the sleepy whistles of a White-throated Sparrow mingle with the melodies of Canada and Magnolia Warblers. A painted turtle clambers onto a sundew-painted log and stretches out its legs to bask in the sun. Nearby, the water boils softly as a bull moose feasts on the leaves and stems of water-shield. Farther out in the golden waters drifts an unperturbed loon, her downy chicks riding contentedly on her back.

Algonquin's summer is saturated with life. Insects dominate the landscape by day and by night. They are everywhere, in the waves of orange hawkweed along the highway's edge, under the loose bark of a fungus-encrusted log, on the floating leaves of a fragrant water-lily. Every possible resource is exploited by these marvels of the animal

world. The caterpillars of ghost moths feed on the submerged roots of alders, the grubs of wood-boring beetles gnaw noisily on the wood of pines, feather-winged beetles dine on the fungal spores, moose fly larvae feast on decomposing moose feces, carrion beetle grubs devour the rotting flesh of a deer mouse, flattened beaver beetles exploit the debris next to the skin of a living beaver.

On hot days the air vibrates with the buzz of cicadas. As the sun fades, the annoying whine of mosquito wings joins the raspy chorus of crickets and bush katydids. Courting fireflies punctuate the darkness with eerie flashes over bogs and other wet places.

Life for these small creatures is rarely long. The promise of sweet nectar, which lures many insects to flowers, frequently turns out to be a fatal attraction. Death often lurks near the beauty of a petal, for crab spiders and assassin and ambush bugs lie there unseen. Nearby, the bulging eyes of robber flies scan the horizon for an airborne meal.

Frequently the flowers themselves present a risk to insects. Out in the floating world of the bog, the strange vase-like leaves of the pitcher plant lure victims down a slippery slide to a watery death. The hairbrush leaves of tiny sundews entrap their prey with droplets of glue, then slowly envelop the catch in a lethal embrace.

By day, insects fall prey to scores of the Park's birds. Barn Swallows swoop low over placid waters, scooping through swarms with open beaks. In the dimness of the maple forest, an Eastern Wood-Pewee drops from its elevated perch, quickly returning with a winged prize in its bill. A Brown Creeper spirals up a towering pine, its sharp eyes and beak probing hidden crevices. Through the leafy jungles wood warblers glean insects from every hiding spot.

Even under the blanket of darkness, danger lurks for those who break its stillness. Undetected by human ears, shrill pulses of a patrolling little brown bat pinpoint a fluttering underwing moth. A sharp crunch marks the demise of a scurrying ground beetle, done in by the poison bite of a short-tailed shrew.

In an Algonquin summer, hungry mouths beg for food everywhere. For many animals, the prolific array of insects provides much of the fuel their growing offspring demand. For others, however, nourishment in the form of larger prey is imperative. Weaned from the milk that sustained them during their first weeks, red fox pups devour the continual stream of small rodents brought by their parents. Timber wolves return to their pups, regurgitating a chunky meal of beaver killed and consumed at some distance from the den.

While struggles for survival erupt between predator and prey, battles of a different sort are occurring in the forests. The life-producing sunlight, once flooding the forest floor, is now intercepted by the net of leaves overhead. Gone are the ephemeral flowers of spring, for they cannot survive in the shade of the trees. Yet, new flowers rise to challenge the darkness. Some, such as the round-leaved orchid, bear huge basal leaves to capture as much of the scant offerings of light as possible. Others survive without needing the solar embrace, fed by fungi attached to their roots. Through an underground association of this type, spotted coralroots absorb nutrients from the decaying bodies of leaves. After the coralroot flowers wilt and expire, the ghostly stalks of Indian pipe thrust through the litter. These bizarre flowers, using fungal straws, thrive on nutrients stolen from the roots of nearby trees.

Although a few have evolved to survive in the shade, the majority of summer flowers grow wherever sunlight is unobstructed. Along the open shoulders of the highway or the embankments of streams, a profusion of flowers flourishes throughout the heat of this season. Frequently arriving by the unknowing actions of man, foreign species such as hawkweeds, mulleins and daisies dominate the roadside scenes. However, along the moist edges of lakes, rivers and streams, the majority of flowers are true native plants. Their unusual names — such as mad-dog skullcap, monkeyflower and boneset — conjure up bizarre images.

With the passage of summer the melodious evening concerts of thrushes begin to fade. With their nestlings now fledged and on their own, songbirds no longer need territories, and their vocal advertisements soon diminish. Gradually, nesting birds fall silent, and through the whole of Algonquin the absence of song is pronounced. A loss of color accompanies the loss of song, for now the need to hide from danger overcomes the need to attract a mate. The rainbow hues of summer plumage are replaced by more somber tones of camouflage.

As July recedes into August, jewelweeds adorn the shoreline edges. Sweeping bouquets of asters and goldenrods begin to overshadow earlier blooms. Wolf dens are abandoned, and the rapidly growing pups are brought to beaver meadows and old bogs, open areas known as rendezvous sites. Left to pounce on leaping grasshoppers, the pups hungrily await the return of the pack. Joyful howls fill the air when the meat-bearing adults finally appear.

In August, eastern waterways are bordered by the most brilliant of floral displays. Here, along the rocky shorelines, fiery cardinal flowers flame intensely. Like miniature helicopters darting to and fro between the crimson blooms, hummingbirds gather nectar prior to their migration south.

The nights begin to cool. A strange restlessness overcomes many of Algonquin's residents. Some busily prepare for impending journeys to warmer climes. Others remain and with the approach of autumn enter a new and dramatic stage.

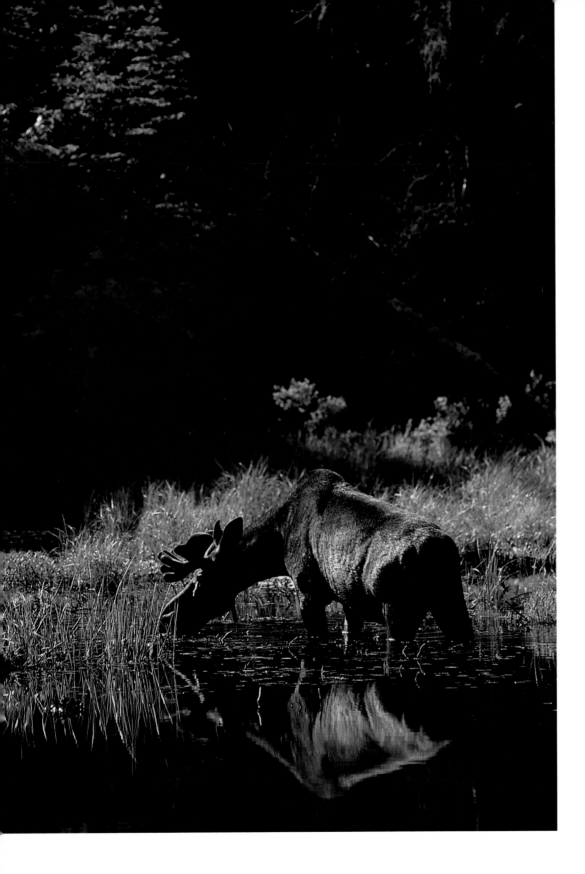

The shallows now support a rich array of succulent plants. In the early morning or late afternoon, moose seek out and eagerly devour this lush vegetation.

A few of these giants find a sodium supplement along the roadsides of spring, but all moose acquire their main source of this mineral in these aquatic plants. Some of these plants contain sodium concentrations five hundred times higher than those of the terrestrial components of the mooses' winter diet. Although water-lilies and pondweeds are also eaten, moose in Algonquin prefer the delectable water-shield.

From every coniferous tract, the dreamy whistles of White-throated Sparrows fill the summer's warmth. Most of Algonquin's pairs are composed of two color variants. Some individuals sport white head stripes; on others these are tan. White-striped individuals, regardless of sex, are more aggressive, while tan-striped birds are better providers for their young. It is possible that a combination of these qualities makes for a more successful nesting endeavor.

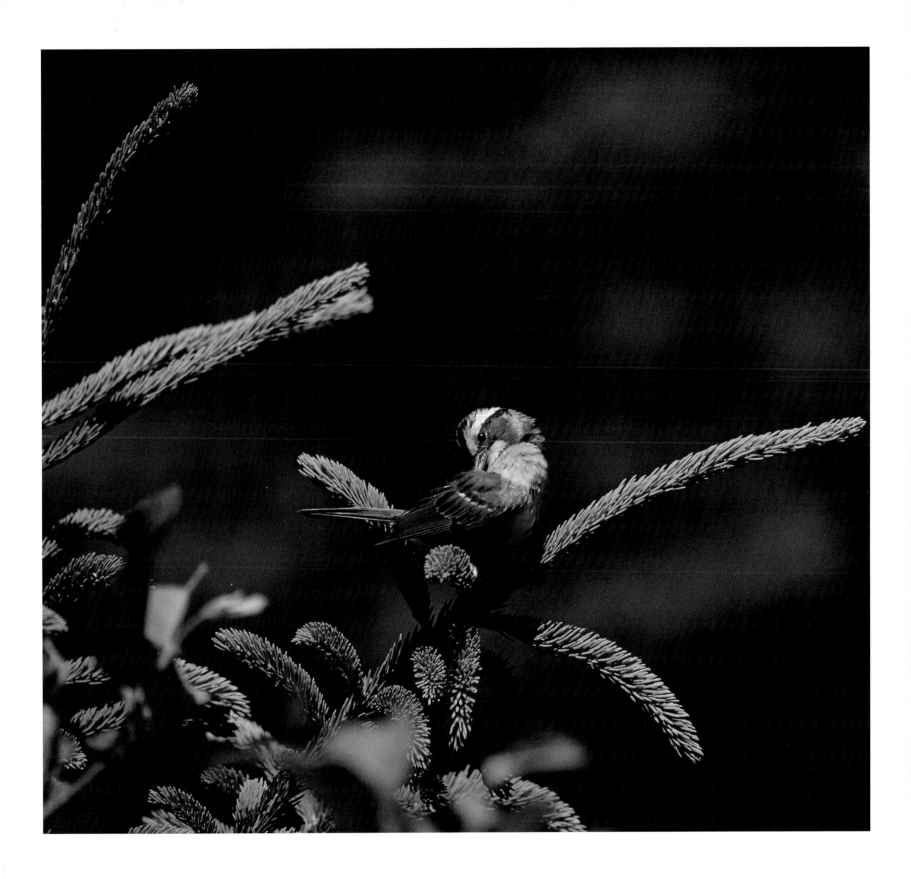

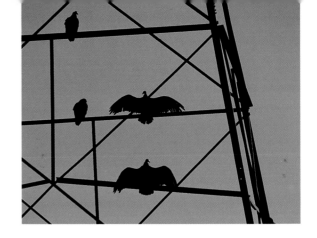

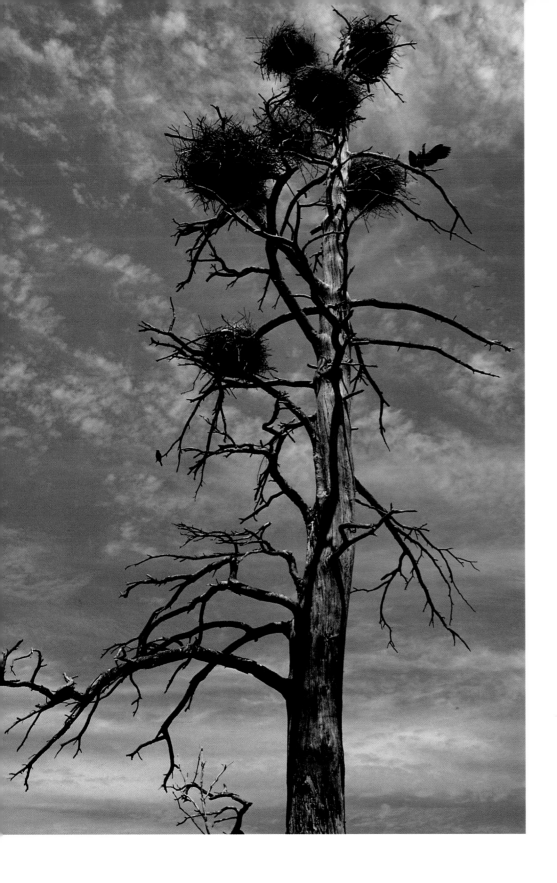

Many of Algonquin's feathered inhabitants prefer more natural haunts, but hydro line towers offer Turkey Vultures excellent roosting sites. Originally absent from the Park in earlier years, vultures have spread north to this region and now can be viewed regularly. These exploiters of death, equipped to glean food from even the most putrid corpse, have benefited greatly by the development of northern highways and their inevitable adornment of animal fatalities.

Great Blue Herons construct bulky stick nests in either living or dead trees. Many of the trees used, such as this towering old pine, hold a number of nests, which may all be active at the same time.

This high-rise tenement on an island in the Little Madawaska held nine active nests, each containing several squawking young.

The rugged rock faces bordering clear lakes and rivers offer birds a variety of more primitive nesting sites. A canoe trip past the awe-inspiring cliffs of the Barron Canyon takes one back in time, for the birds found here are surviving as they have for thousands of years.

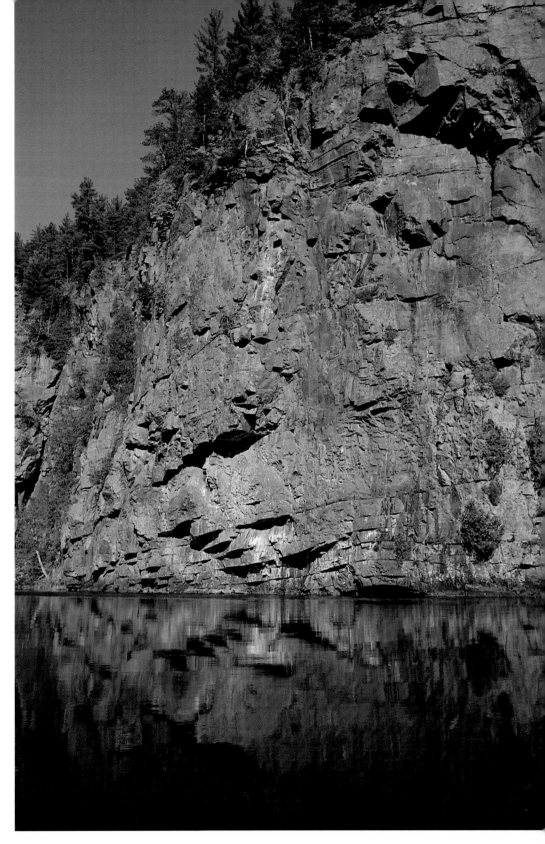

Generally placed under an overhang for protection from the elements, the nests of Barn Swallows are cemented to the rock. The rocks below, prolifically adorned with flowing streams of excrement, reveal that this nest is currently in use. Not all nests such as this one belong to Barn Swallows, for those of Eastern Phoebes share the same recesses.

Butterflies rule the daylight hours, but the night belongs to the moths. Hiding through the sunlit hours, many moths have cryptic patterns, which blend into the bark of trees. Some, such as this apple sphinx, show a striking pattern on the usually hidden hind wings. When displayed, the pattern startles an attacking predator, thereby allowing the moth to escape.

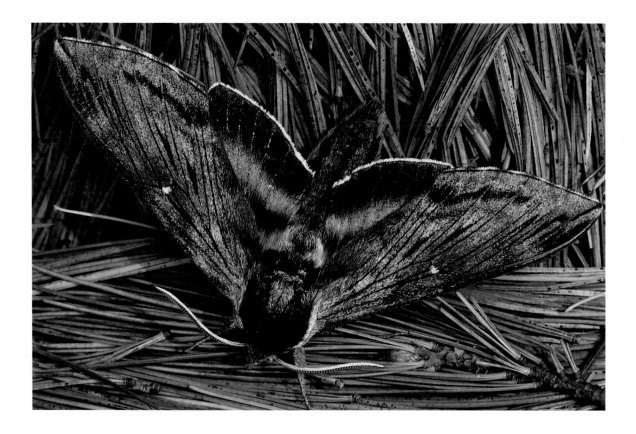

With long, cold winters unfavorable to many reptiles and amphibians, Algonquin supports a relatively low diversity of these ectothermic ("cold-blooded") animals. However, the hardy species that do occur tend to be rather common.

While many of the spring voices have fallen silent by this season, others, including bullfrogs, are just starting up. Males, identified by a tympanum or eardrum that is larger than the eye, stake out a territory and strive to attract females with their rumbling baritones.

Sensing the air for any sign of prey, a garter snake silently searches at a pond's edge. The tongue picks up scent molecules and transfers them into the roof of the mouth. Here, in a sensory center known as the Jacobson's organ, these airborne clues are analyzed for information. Garter snakes are the most common snakes in the Park, and feed mainly on worms and frogs and their kin.

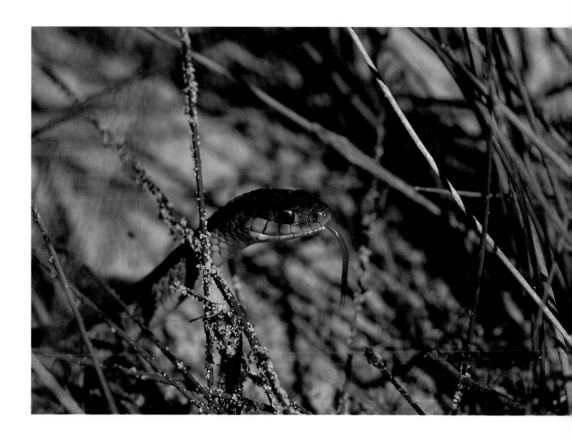

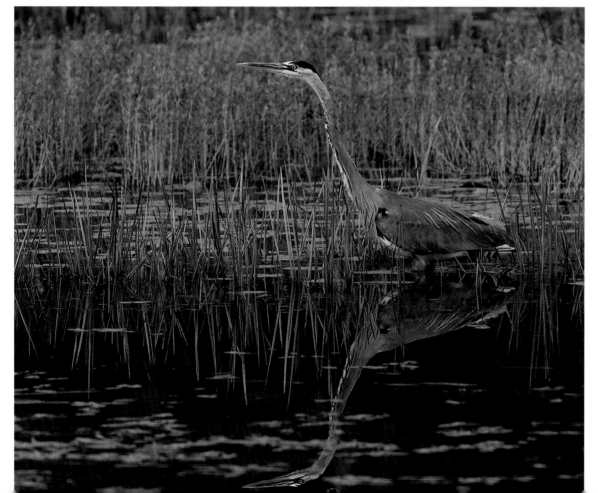

Great Blue Herons, the largest birds known to nest in the Park, frequent these wetlands where frogs and fish reside. The herons stand motionless while intently studying the water below, then with lightning speed snatch their prey with long, spear-like beaks.

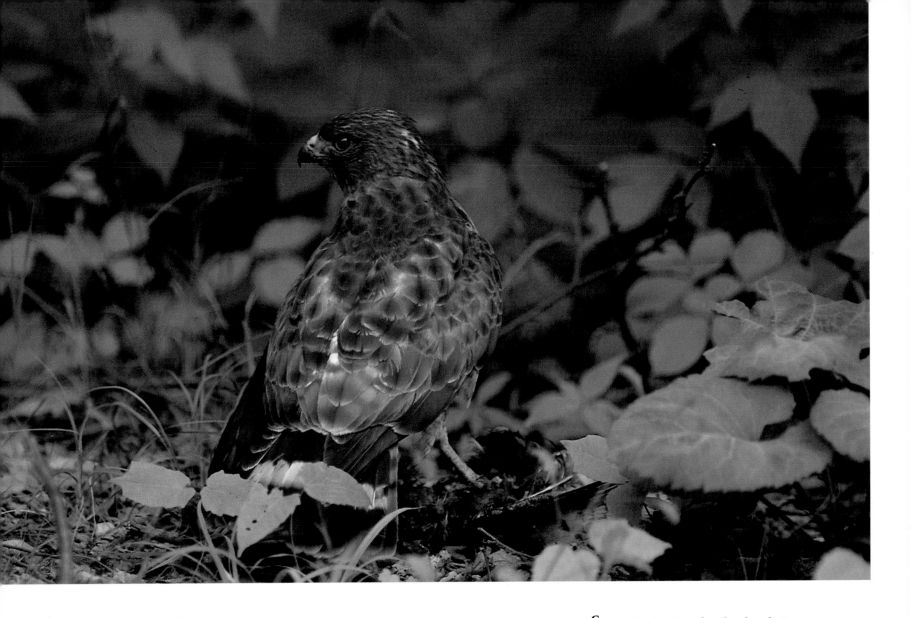

Although generally known to tackle much smaller birds or snakes and frogs, this Broad-winged Hawk is feasting on a Ruffed Grouse. These rather tame hawks are most commonly seen sitting patiently on roadside telephone lines.

Spring is the time for the thundering drummings and elaborate performances of male Ruffed Grouse, but summer is the scene of distraction displays by alarmed females. With her precocious chicks hiding beneath bark and leaves, a hen desperately tries to draw danger away with alluring postures and persistent clucking.

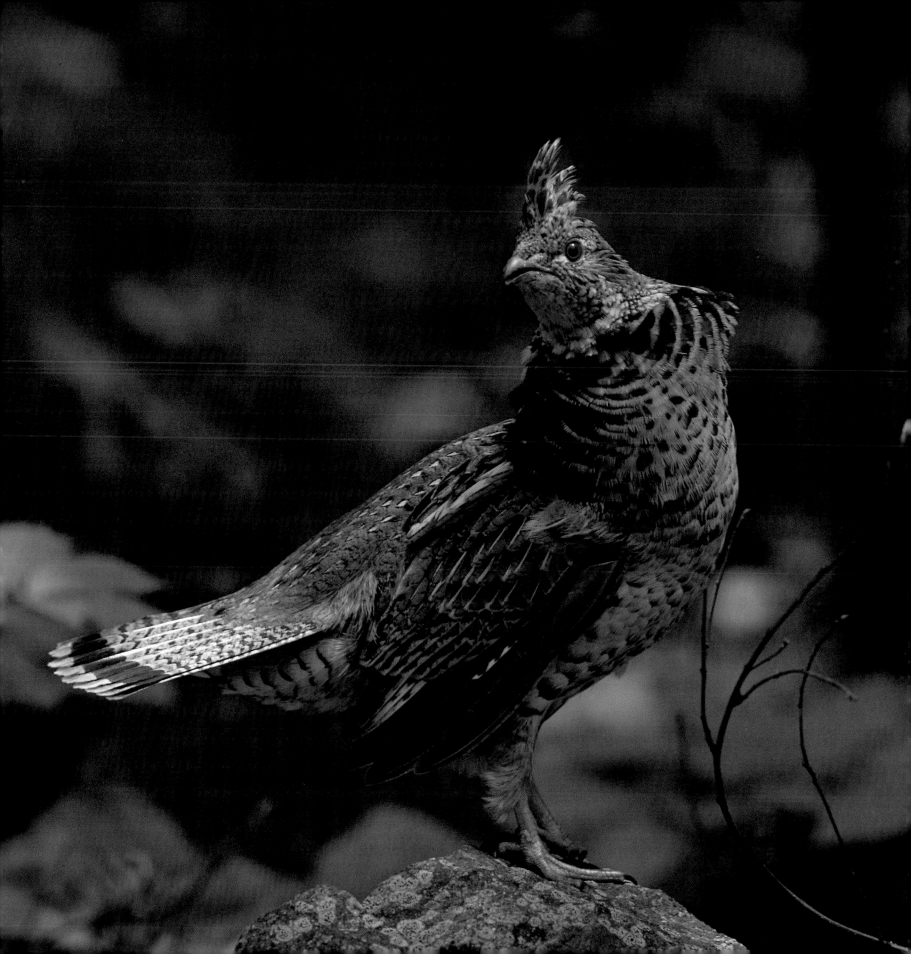

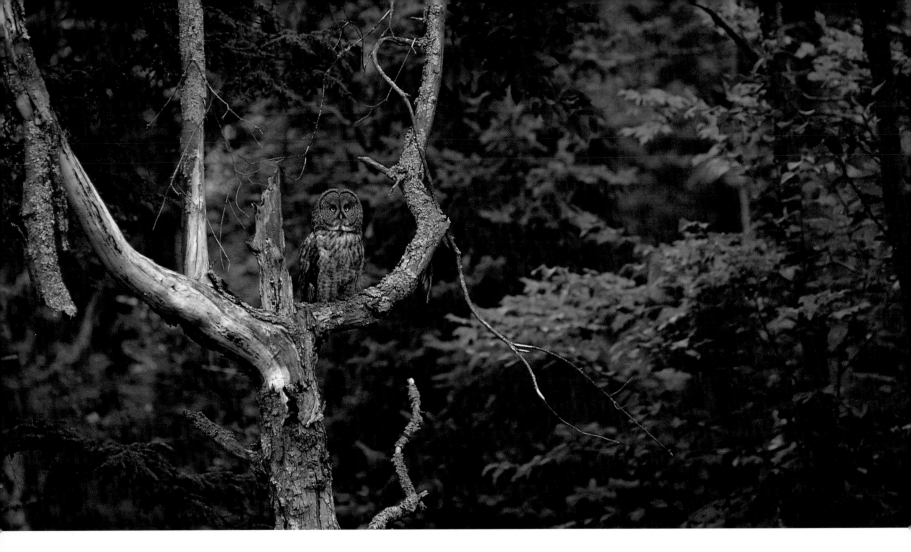

Barred and Northern Saw-whet Owls are the only owls known commonly to nest in Algonquin. Great Gray Owls, affectionately referred to by some as phantoms of the north, are usually found in areas much farther to the north and west. They were rarely known to wander into the reaches of the Park, even during winter influxes into regions well south of their known breeding range.

However, in the summer of 1989 a wolf researcher reported sighting one of these stately birds near a boggy creek to the east of Opeongo Lake. The next day at sunrise, a few other naturalists and I arrived at the scene. When I imitated the squeal of an injured animal by sucking on my fingers, an adult silently flew in. Perching on this limb, it stared our way defiantly.

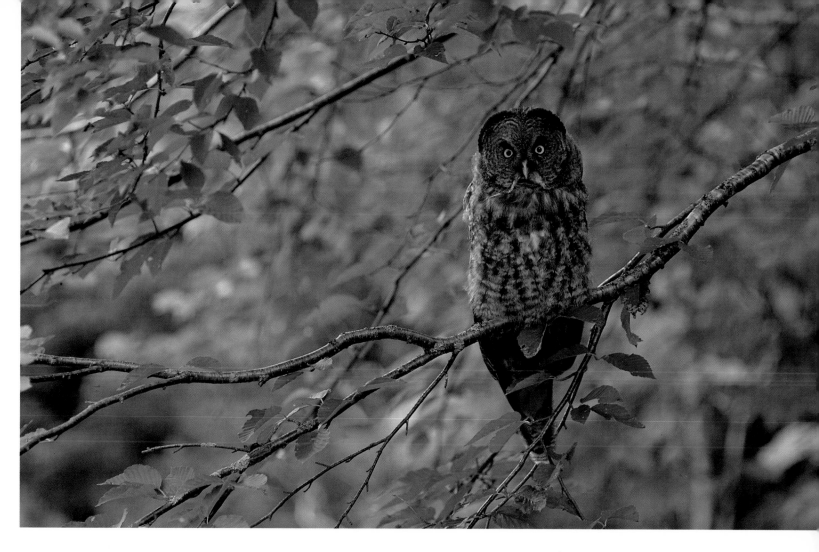

As we excitedly admired this noble creature, from behind came the begging cries of hungry young owls. This fledgling Great Gray Owl and its two siblings also appeared, their curiosity aroused by the persistent squeals I was producing. This successful nesting, a superb example of how the presence of northern habitats provides opportunities for northern life, represented the southernmost ever recorded for this species in all of Canada.

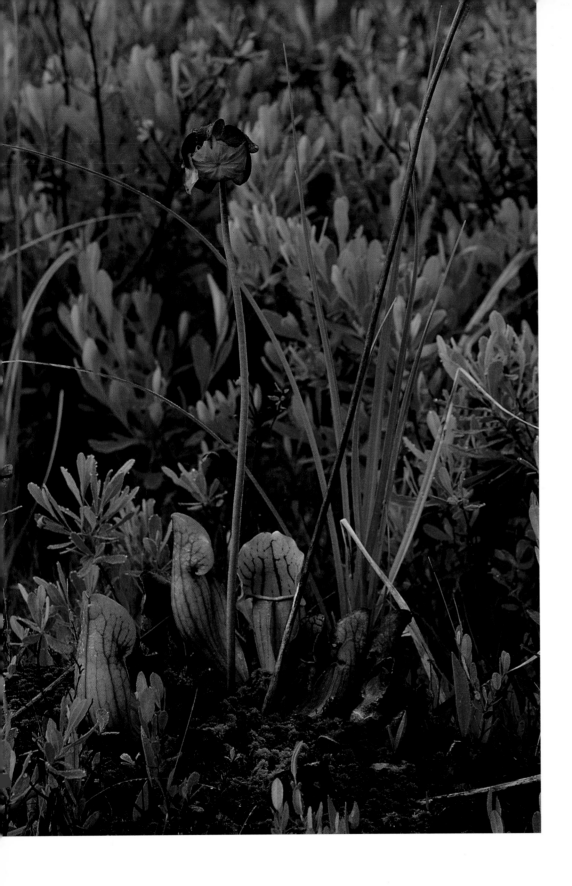

Perhaps my favorite of all the Park habitats, Algonquin's floating bogs perpetually support a diverse and remarkable array of plant life.

Ominously towering over the surrounding sweet-gale, the peculiar flower of a pitcher plant appears to survey its domain. Even more bizarre in form than the flower above, the modified leaves that capture insect prey sprout like a cluster of vases from the mosses below.

In the nutrient-deprived world of the bog, a common survival tactic for plants is the theft of life-giving elements from insects. Round-leaved sundews capture the insects with globs of glue perched atop tactile hairs. Once their prey is entangled, it is enveloped by the leaf. Slowly, through enzymatic actions, it becomes a liquefied meal. The right leaf of this sundew has completed its task and has unfolded, discarding the severed body of a hapless damselfly.

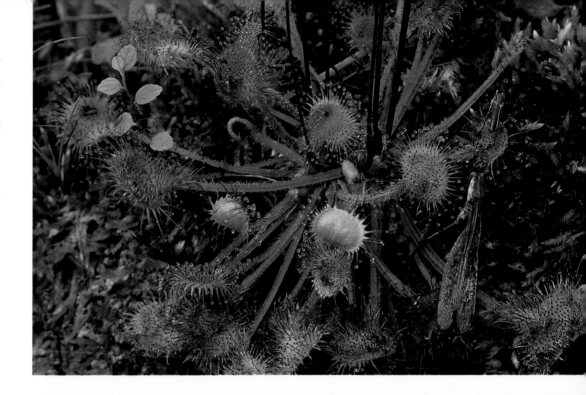

The floating mats of sphagnum moss are also home to the resplendent blooms of wild orchids. Mimicking the color and form of bog flowers that for visiting insects offer real rewards, the unscented flowers of grass pink instead hold surprises aplenty.

The uppermost petal appears to bear the nectar and pollen-producing structures eagerly sought by many insects. However, upon landing on these imitations, the fly or bee is rudely exploited. The weight of the insect causes this petal to fall, and traps its passenger in a winged trough below. As the surprised creature struggles to escape, any pollen it might be transporting from an earlier incident is removed, and a new load is applied just before it flees.

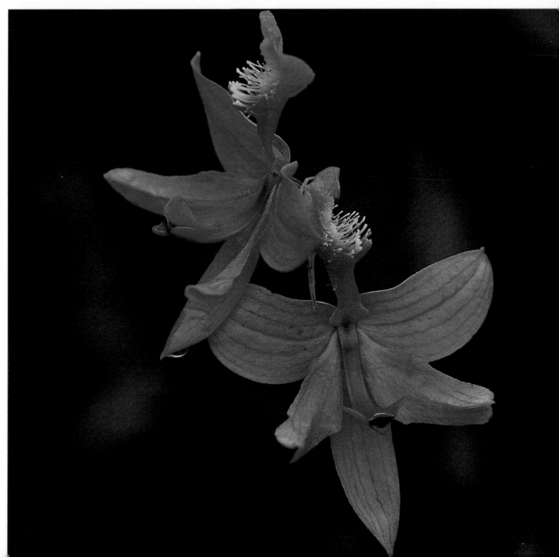

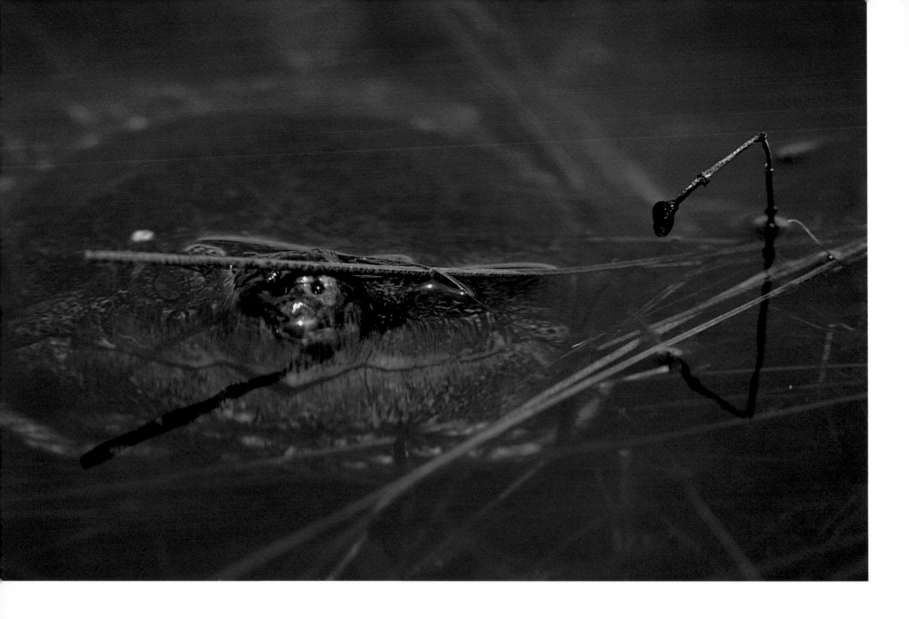

While the surface teems with an abundance of life, danger patiently lurks below. Rarely seen out of the water unless laying eggs, snapping turtles are usually undetected as they lie submerged. The sound of the air being sucked into its nostrils alerted me to the presence of this fierce-looking turtle.

Although aggressively defensive when held at bay on land, in the water these aged creatures usually swim away from any threat, perceived or real. While their diet includes live animals, such as small ducklings, these large turtles primarily scavenge the bottom for any dead item.

As the light dissipates and resting moths begin to stir, many flowers close their blooms to await the following morn. While many of its neighbors are hiding from the night, the blossoms of evening primrose are unfurling for their show.

Primrose flowers are designed to attract specific moths that fly shortly after dusk, and conceal not only their beauty but also their sweet fragrance during the long, hot day. Thus conserving energy that would otherwise be wasted, these flowers present enticing gifts only when their nocturnal pollinators fly.

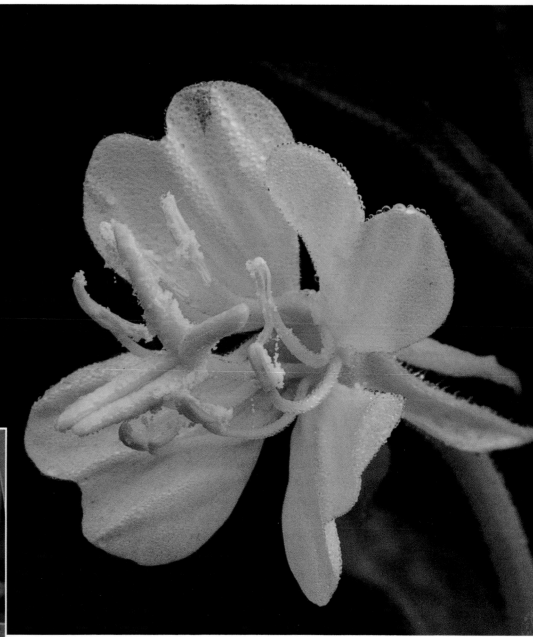

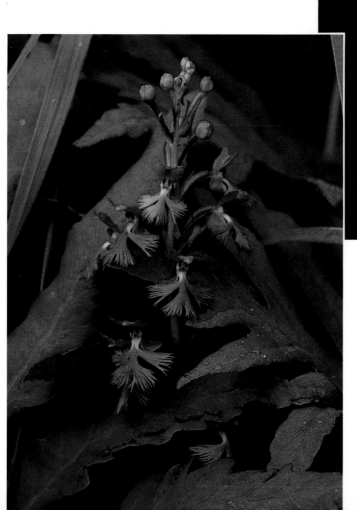

Purple-fringed orchids, one of the most exotic of all Algonquin plants, are found only in the east. Preferring floodplains along the Petawawa and Barron rivers, this delicate orchid has flowers reminiscent of tiny faces.

Intercepting most of the light with an umbrella of leaves, the hardwood trees impose dark restrictions on the plants that grow below. Maple seeds are well provisioned to supply their germination and initial growth. However, unless the canopy opens up, allowing the sun to flood the floor, the young seedlings can survive for only a handful of years at best. But almost immediately other seeds will germinate, and new maples will replace the dead. Through this continual replacement of themselves the maples' dominance is complete.

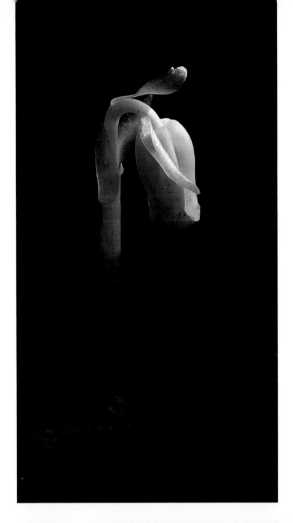

As this season ages, ghostly heads of Indian pipe rise through the darkened domains. Resembling more a fungus than the flowering plant it be, this pallid flower survives as a parasite, deriving its nourishment from a fungal pipeline attached to the roots of trees.

Surviving with little need for sunlight, spotted coralroots thrive in darkened woods by exploiting the decaying litter on the forest floor. This mottled orchid could not live its saprophytic ways without the aid of a fungal association with its roots.

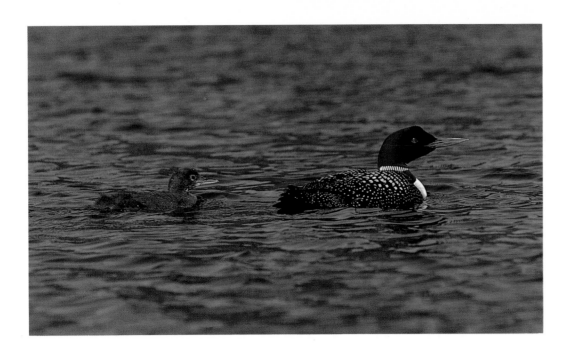

On every lake the water is graced by loons with young in tow. Slow in developing, loon chicks stay with the parents right into the fall. When small, the downy chicks can often be seen riding on the adult's back.

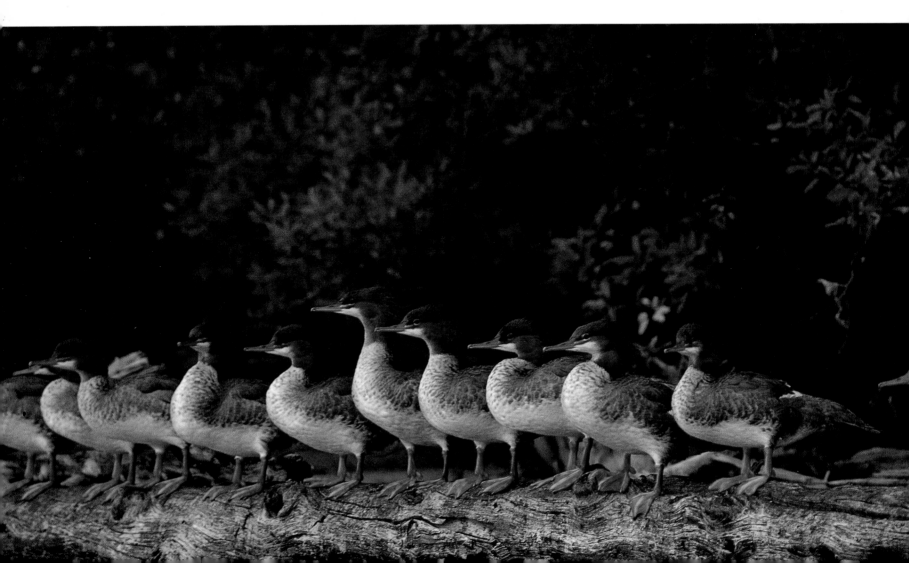

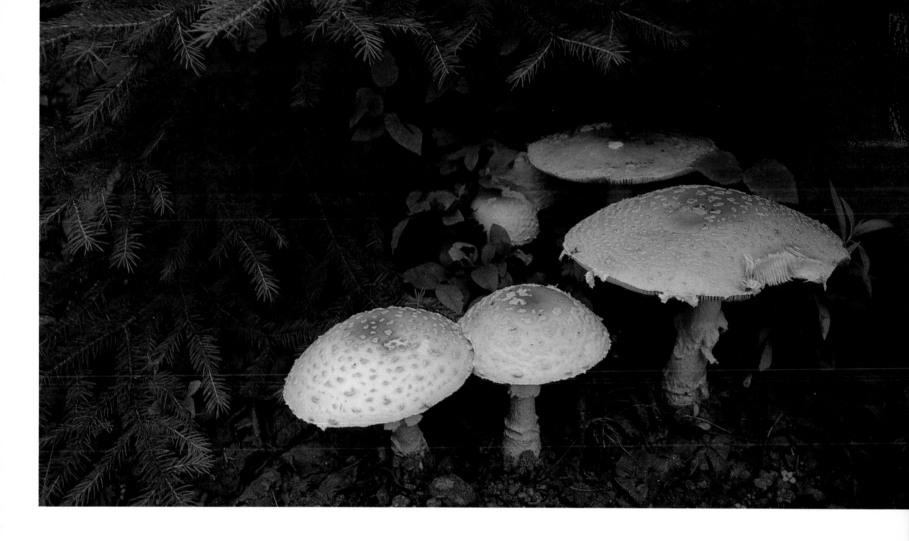

A female Common Merganser produces only a dozen young or less, but much larger congregations are commonly seen by late summer. Known as creches, these groupings are composed of several different broods.

One theory for these aggregations is that unhealthy females wishing to replenish reserves before fall migration dump off their young with other mothers. Recipients of these broods sometimes do not reject them, for by having more young present, the odds are improved that their own offspring will survive if a predator threatens.

The advanced young in this photo were part of a group totalling an amazing fifty-four birds.

One of the more glamorous of mushrooms, the fly agaric is far more beneficial to the nearby spruce than it is to a human. Through its network of thread-like hyphae that travel through the soil, this nauseous fungus supplies nutrients to the roots of birches, poplars and conifers.

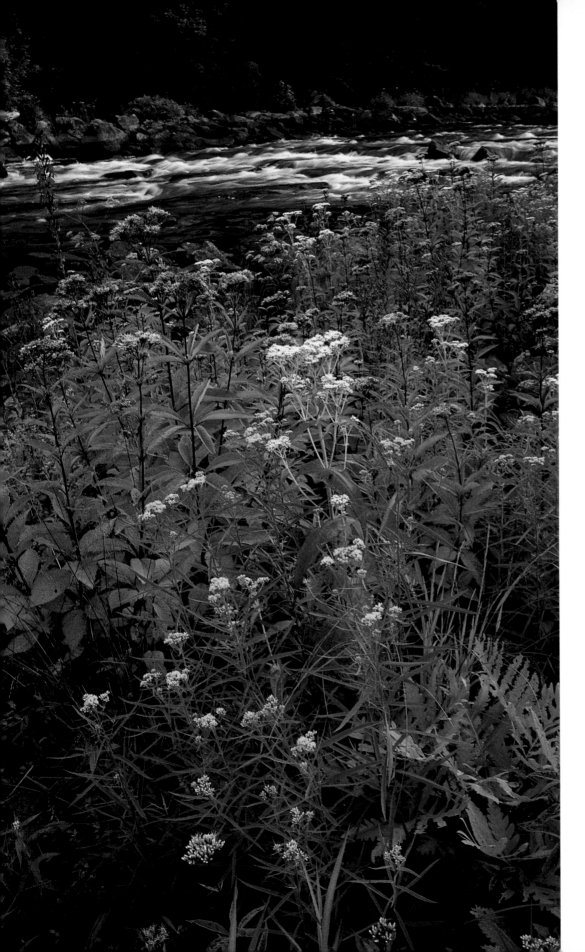

A *magnificent eulogy to summer's demise, the most spectacular of floral displays erupts along the rocky flood-plains of eastern rivers. The blazing yellow of grass-leaved goldenrod, the blushing pink of joe-pye weed, the brilliant white of boneset and the scarlet flames of cardinal flower blend to create this symphony of color.*

The most breathtaking of all, the fiery blooms of cardinal flower do not entice insect visitors. Rather, these elegant lobelias are designed to be pollinated by the probing efforts of hungry hummingbirds.

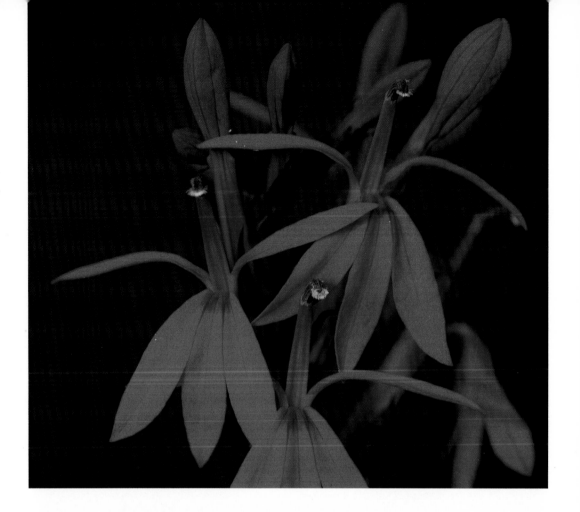

Transporting a mass of white pollinia on the base of its bill, this hummingbird will lose its package when it visits another bloom with its female parts exposed.

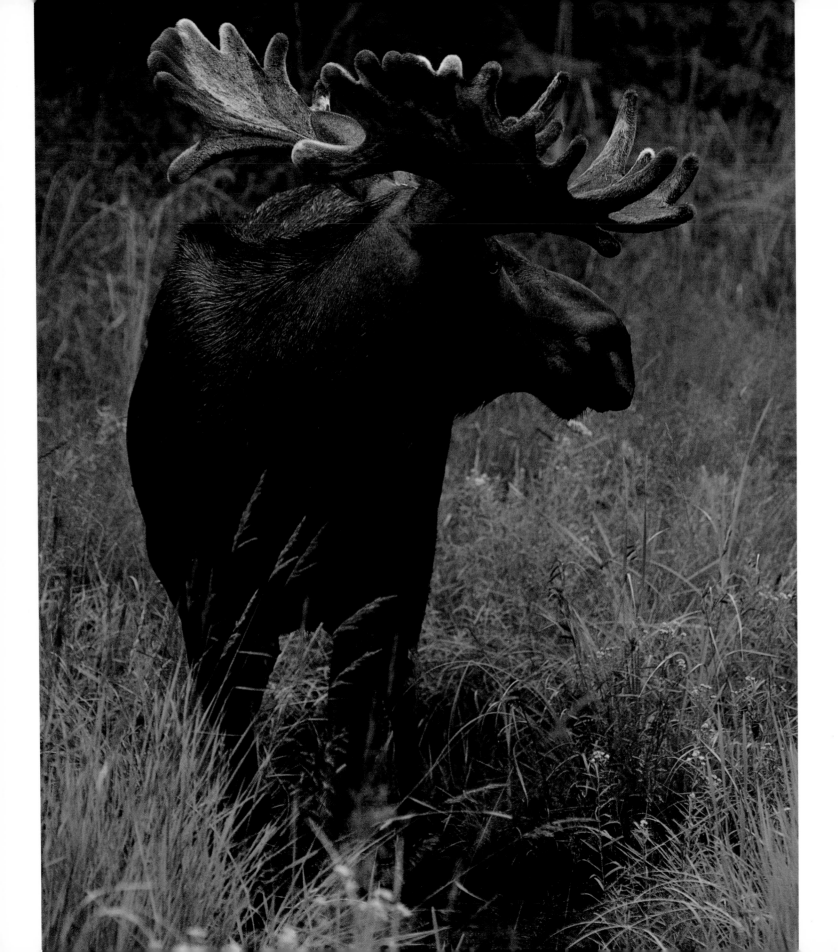

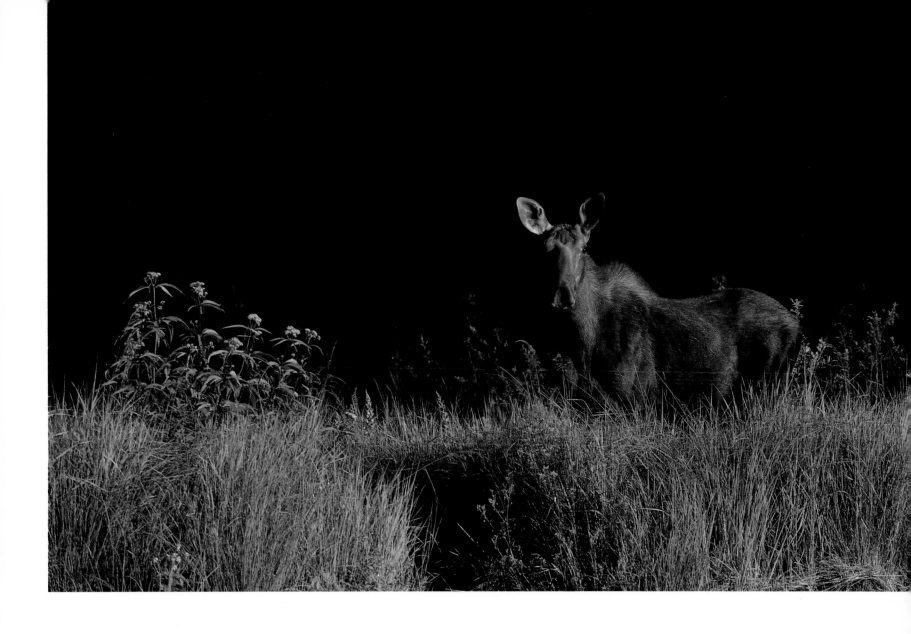

Through the summer, a plush skin known as velvet covers the antlers of bull moose. These huge bony structures are grown in one season only. During the fall they are used primarily for display, not fighting.

As summer draws to an end, hormones begin to alter the appearance as well as the behavior of moose. The arrival of fall heralds the commencement of their breeding season, the rut.

Season of Splendor

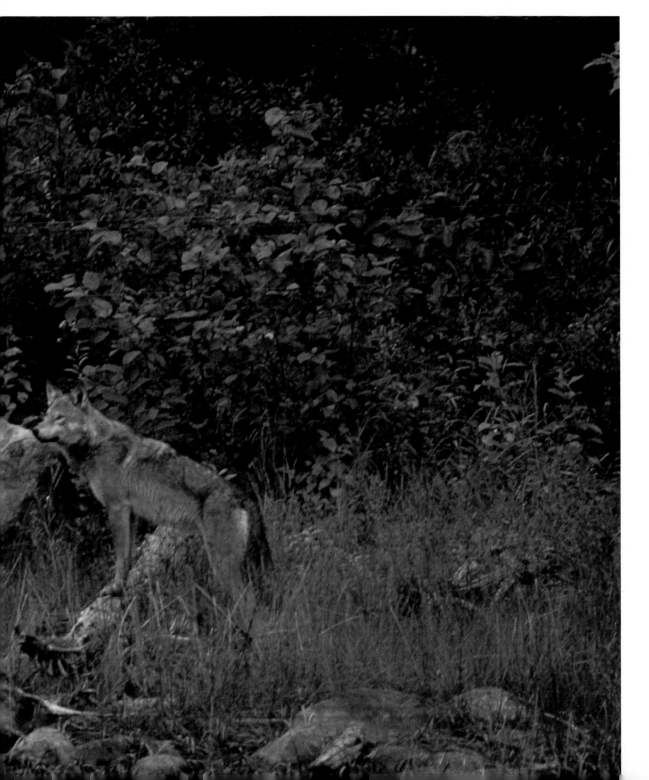

The crisp air of autumn induces profound changes in both the landscape decorum and the behavior of animals. While some prepare for treacherous journeys to distant lands, other animals, such as the wolf, simply wander more widely.

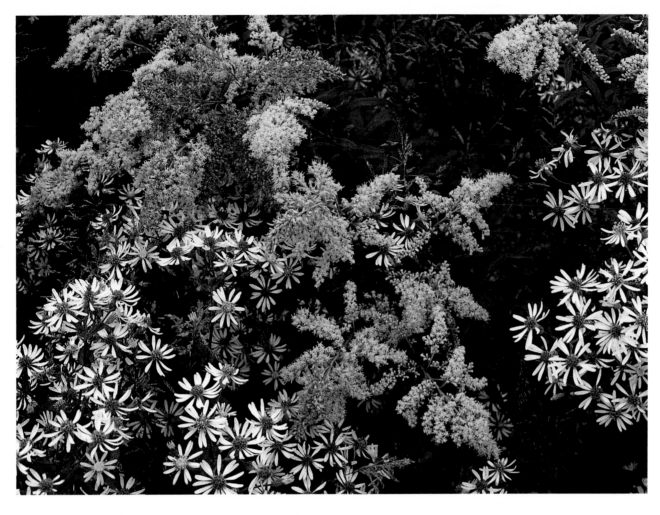

Only the hardy flowers of goldenrods and asters remain to challenge the overnight frosts of the fall. While they face considerable hardship by blooming late, they capture all the attention from the insects that still fly. Canada goldenrod and purple-stemmed aster dominate this season.

A S THE DAYS SHORTEN and the night air acquires a penetrating chill, life in Algonquin develops a faster, at times almost frantic, pace, for winter hardships loom ahead. For many, the fall triggers the motivation to escape to warmer climates. Overhead, the crisp night air is at times filled with the shrill peeps and cheeps of small migrants winging their way southward through the darkness. The woods are no longer filled with the spectacular songs of summer, and the glow of dawn is greeted only by the distant babble of passing geese.

But for those that cannot escape to southern haunts, the autumn is a time to prepare for the onslaught of the most unforgiving season of all.

New plush coats of winter hair begin to grow on foxes, wolves and the other fur-bearing residents. Outer hairs lengthen and thicken

while beneath them an underfur forms. Together, these lavish layers of hair provide the animal not only with a luxuriant appearance but also with a life-saving cloak of protection against the impending frigid temperatures.

Innately aware that meager times lie ahead, many animals devote their energies to feasting and caching food. Chipmunks hustle to fill their subterranean winter stores with life-sustaining seeds. Gray Jays ceaselessly stash morsels of plant and animal flesh under bark and in crevices, first covering each piece with a sticky coating of saliva, which not only holds the food in place but also may preserve it. Black bears scale towering beech trees to fatten on the nuts, storing energy that will carry them through their winter slumber and sustain them in the early spring to follow. Beavers venture far from the safety of their aquatic havens to fell poplar trees, returning with the branches to be stored in a pile and later exploited under winter's ceiling of ice.

Foraging dominates the autumn activities of some animals. For others, however, the arrival of fall triggers an urge to propagate. The frigid dawn air reverberates with the nasal bawls of cow moose seeking to attract a mighty bull. The crashing of antlers on wood and a strange cough-like call announce the arrival of a hopeful suitor and the beginning of elegant and at times dramatic courtships. Few of Algonquin's scenes cause one's heart to pound more strongly than the sight of a towering rack of bone nodding ever closer through the choking mist.

Meanwhile, beneath the cold surface, new life is stirring. Three months have passed since female turtles laboriously placed their eggs into the ground, and now within the leathery confines of their shells young turtles begin to struggle. Eventually, with the aid of a horny protuberance on their beaks, they cut themselves free into the darkness of their subterranean nest. Some broods may burrow to the surface and crawl slowly to the safety of water; others will pass the winter within the shelter of the earth and tunnel out the following spring.

As turtle hatchlings emerge from the ground, other forms of life are withdrawing into deep and dark retreats. Most of the turtles and many of the frogs will spend the winter in the muck at the bottom of ponds. Snakes, however, seek drier sites and vanish into crevices among rocks and under the ground. Here, safe from freezing temperatures that prevail overhead, they will spend the long, cold months in a stiff, dormant state. Most of these "cold-blooded" organisms must avoid subzero temperatures. A few, however, have marvelous adaptations that permit them to actually freeze. Never far beneath the snow-covered surface of the ground, spring peepers, gray tree frogs and wood frogs await the return of spring to revive their frozen bodies.

Apart from the flurry of animal activity, the autumn also offers visual extravaganzas. The greens of summer are gradually discarded, and leaves begin to flame with radiant color. The rolling hills of hardwoods now blaze with an unrivaled intensity. A million stars burn in the crisp night sky, but these soon pale as the aurora borealis dances its waves across the heavens. Far below, the silence is shattered by a wolf's spine-tingling howl.

The crowds of human visitors that at times invade the summer landscape are now greatly diminished, allowing for a more private communion with Algonquin. A genuine bonus of the season is the absence of biting insects that dominate the evenings of the previous seasons.

As fall comes to an end, cool winds strip the trees of their colorful garb and carelessly toss the lifeless leaves about. Eventually, they settle on the cold, damp ground, coating it with a lustrous veneer.

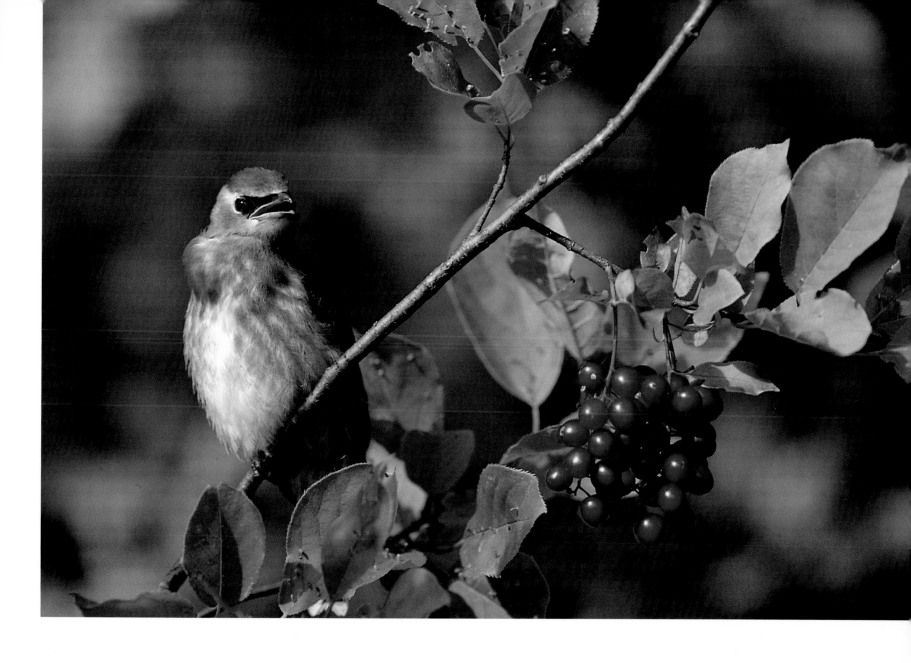

Cedar Waxwings, one of the last birds to nest in the Park, depend on fruit to feed their young. Once the young have fledged, as this waxwing has done, they travel to the source of the fruit to join the adults in delectable feasts.

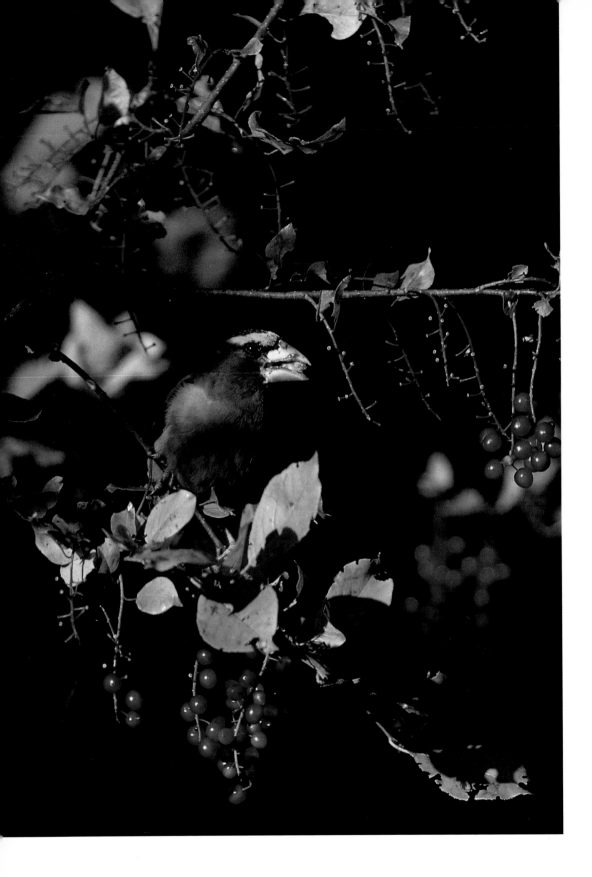

In some years, prolific crops of cherries and other wild fruits laden the branches almost to the point of breaking. In other years, little if any fruit is produced. This adaptive feature, known as "predator swamping," prevents the seed predators from eating all the seeds, allowing some to escape in years of plenty.

With the massive beaks that give these colorful birds their names, Evening Grosbeaks not only devour the soft flesh of the cherries but also noisily crush the inner stones.

Suitable habitat exists for many nesting birds and for some that use the Park only on transitory crossings. For certain species, such as most Arctic-nesting shorebirds, the proper environment is rarely found, making their visitation noteworthy at any time.

When a dry summer precedes a rainless fall, water levels drop precariously, exposing new resources. This is particularly noticeable on the Petawawa system, where shallow sand-bottomed lakes, such as Radiant, are situated. In a year of low water, vast expanses of sand and shallows are formed, providing feeding opportunities for such rare migrants as this Hudsonian Godwit. Unfortunately for those who are fair weather enthusiasts, the best time to view these vagrants is when they are forced down from the sky by violent rain storms accompanying a cold front.

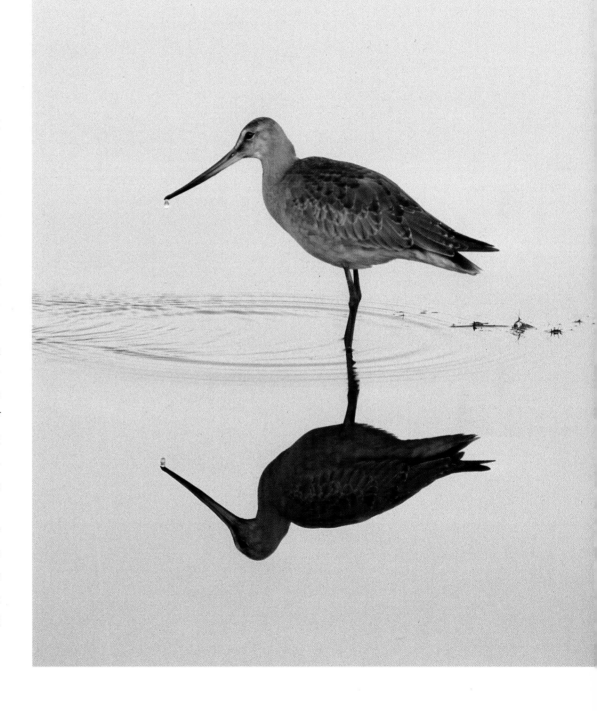

From the middle of September to the middle of October, the early morning silence is shattered by the nasal bawls of cow moose entering their estrus.

Calling loudly from an open edge known as an arena, this hopeful cow listens intently for the distant approach of a potential suitor.

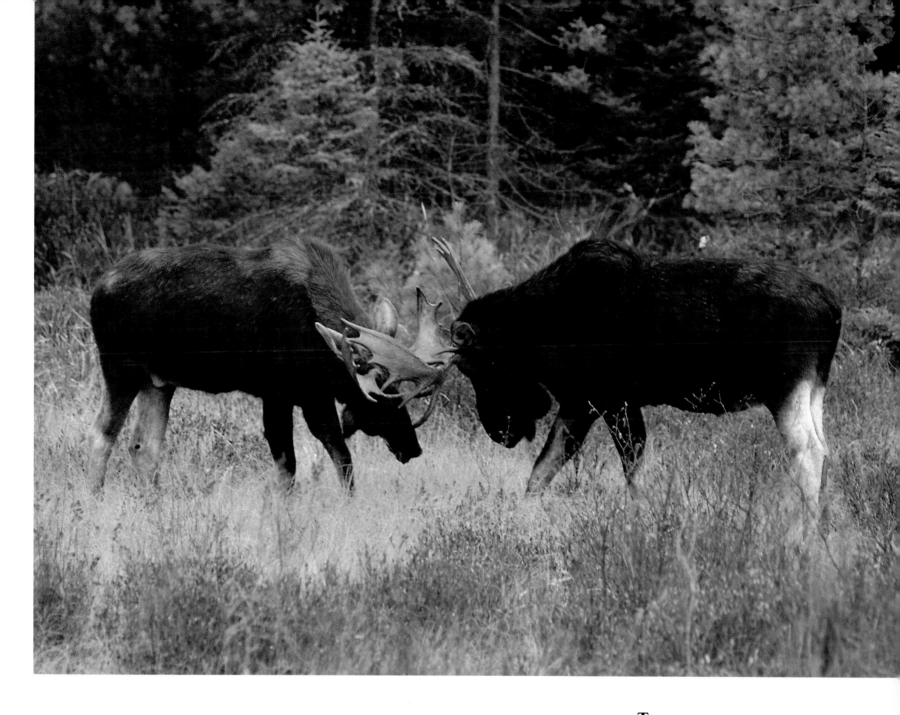

The antlers of bull moose are of paramount importance in communicating status during the rut. Sparring contests establish rank, with contestants rarely incurring injury.

An Algonquin autumn is an exhilarating pageant of vivid color and form. Upon closer examination these dazzling colors may reveal more than just the time of year. Red maples are trees in which the sexes are separate. The leaves on a male plant turn red in the fall; those on the female turn yellow.

By the time the harvest moon beams down on the land, much of the brilliance has faded and regiments of leaves have been discarded to the cold ground beneath.

The growth of a thick, plush coat not only provides for a luxuriant appearance but, more importantly, offers vital assistance in survival by fighting the autumn chill.

Hunters must travel more widely to find food as much of the summer fare retreats into inaccessible haunts. Feeding on anything they may catch, red foxes now comb the sandy sites where turtles dug their nests.

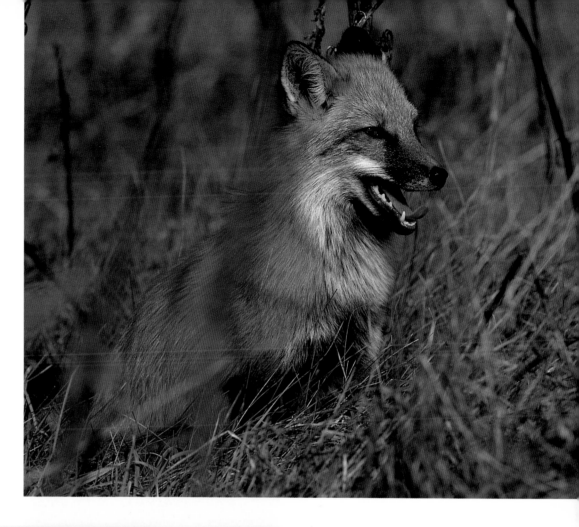

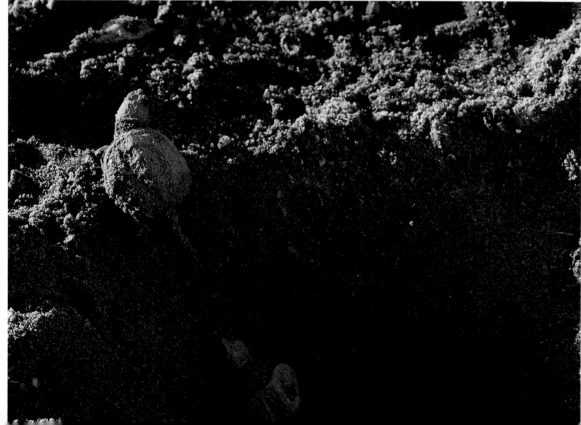

This turtle nest was only partially excavated before the fox was frightened away. Taking advantage of the opening made by the fox, young snapping turtle hatchlings laboriously climb to the surface.

Finally released from its three-month sentence served in dark confines beneath the surface, a baby snapper blinks its eyes as it views daylight for the very first time.

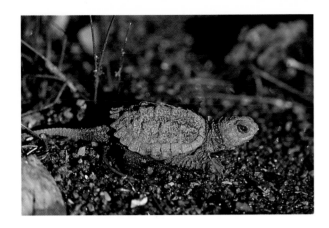

Having successfully descended a rugged embankment that must have appeared as high as a mountain, this snapper enters the cold water for the very first time. This liquid world will be its home for most of its life.

Most turtles and many frogs burrow into the murky bottoms of ponds and shallow lakes to escape the numbing temperatures that crystallize water into ice. Here, in a death-like state, they spend the frigid months, later to be revived by the warmth of spring.

Defying the usual fatal effect of freezing, a select few, such as this wood frog, winter near the ground's hard surface. By allowing ice to form outside body cells, they completely retain their internal integrity. Although over half of all their body water might be frozen, in early spring the frogs will thaw and once again vigorously sing and lay their eggs.

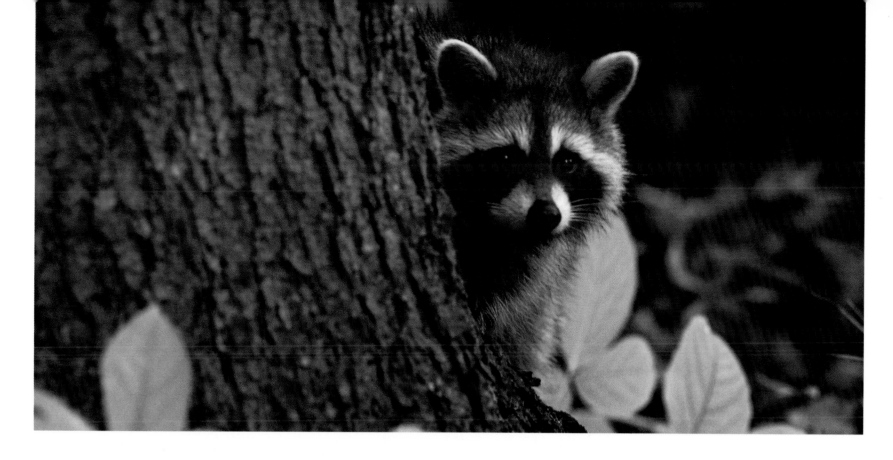

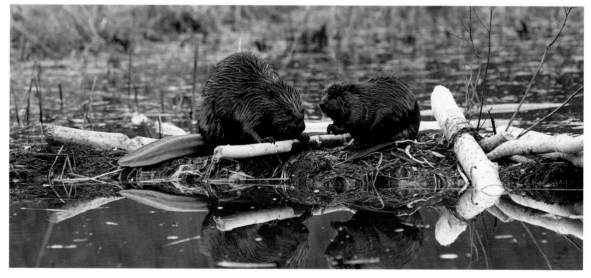

Feasting on frogs, fruit or virtually anything edible, raccoons build up fat reserves in preparation for a lengthy slumber. Raccoons generally winter in the hollow of a tree. Unlike groundhogs, they are not deep hibernators and can be aroused on a warm mid-winter day.

The soft bark of poplar is the woody meal preferred by beavers, although lesser trees are used if this choice is unavailable. By fall both the adults and their smaller offspring enjoy this succulent repast.

Beavers expose themselves to danger by leaving their aquatic world in efforts to create a food pile for sustenance through the winter. Superbly designed for a life in the water, they are sluggish on land and easily captured.

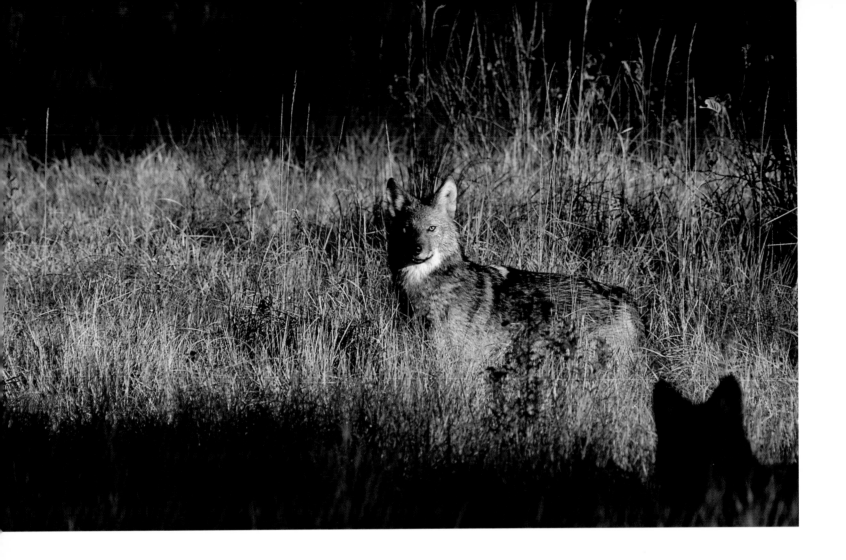

Their curiosity aroused by my howls, two wolf pups have approached to investigate.

The eagerness of wolves to howl back to human imitations of their calls is exploited by the Park interpretive program. During August, if a pack is located along the highway corridor, public wolf howls are held. Each excursion draws well over one thousand excited participants.

The first snows, albeit shortlived this early in the season, temporarily contribute to the Park's visual splendor. A soft covering of a more permanent nature does not usually arrive until the end of November.

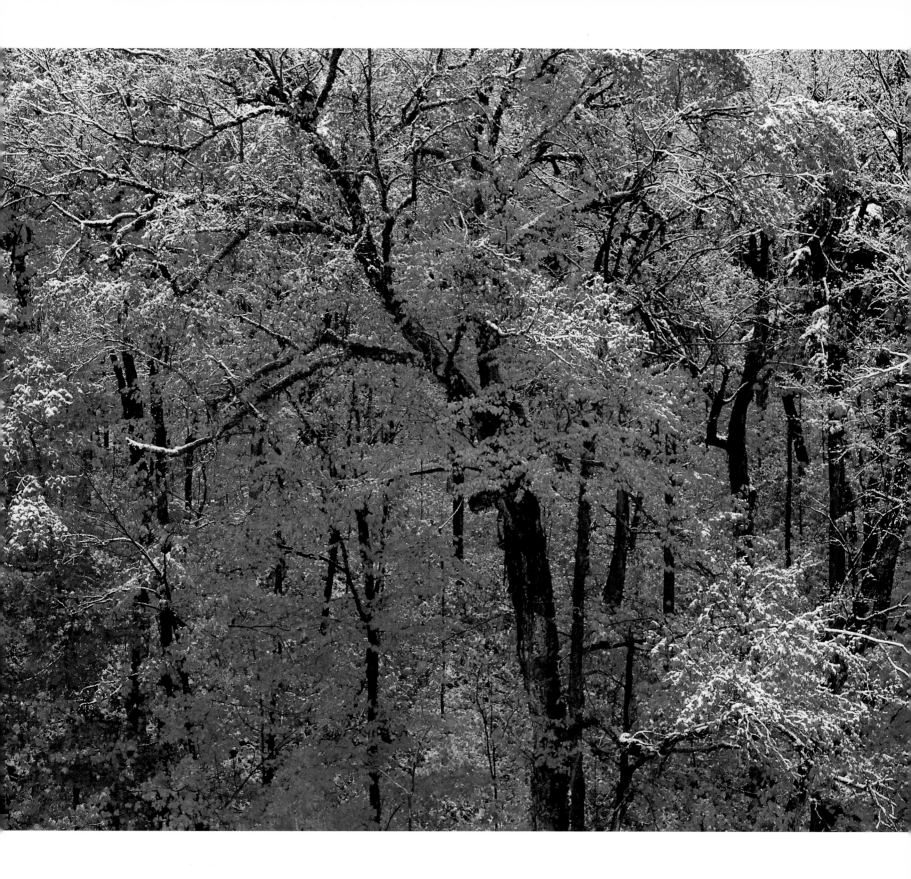

The smooth bark of older beeches not only displays the fresh scratches made by bears climbing the trunks earlier this season but also exhibits permanent scars from previous fruit-bearing years.

Desiring the delicacies borne over-head, black bears climb tall beech trees until the branches refuse to sup-port them. Unable to climb onto frail-er limbs, the bears simply pull them in until they break. After gleaning the tangles of the sweet nuts they crave, the sated bears depart these lofty perches, leaving behind long-lasting monuments to their efforts.

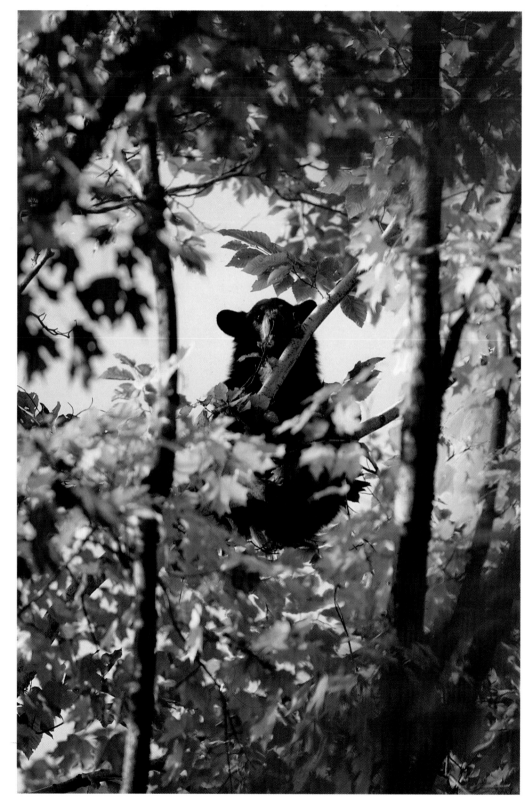

Resembling the nests of some gigantic feathered creatures, tangles of broken branches are testament to the feeding ravages of hungry black bears. Known as "bear nests," these structures, here seen in beeches, can also be found atop cherry trees.

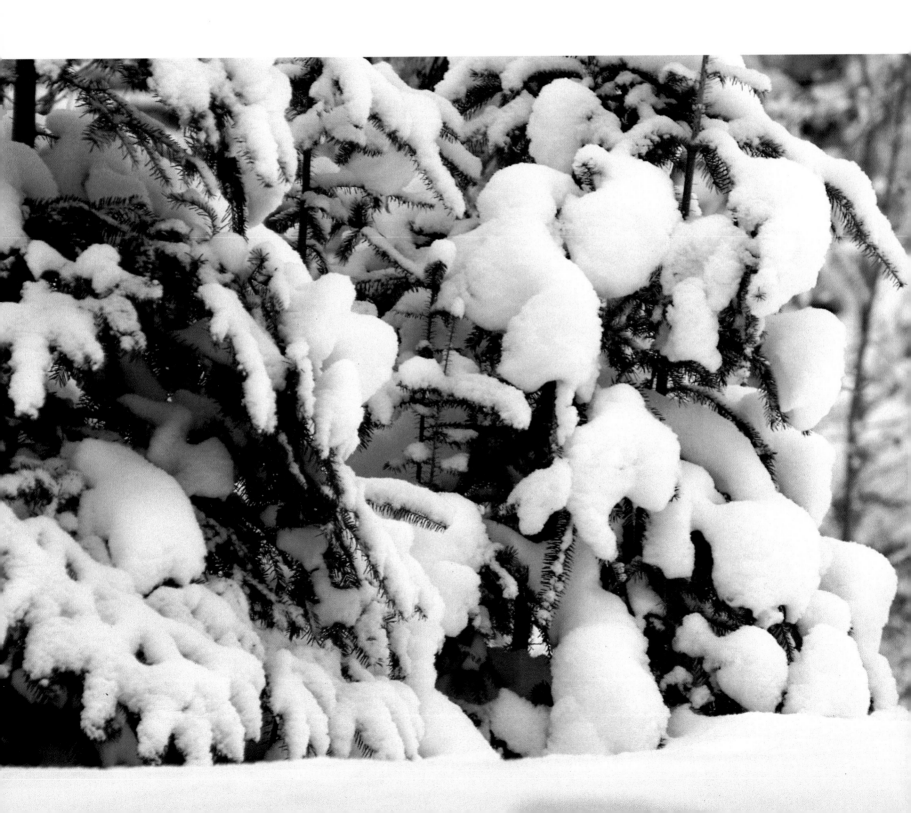

Season of Hardship

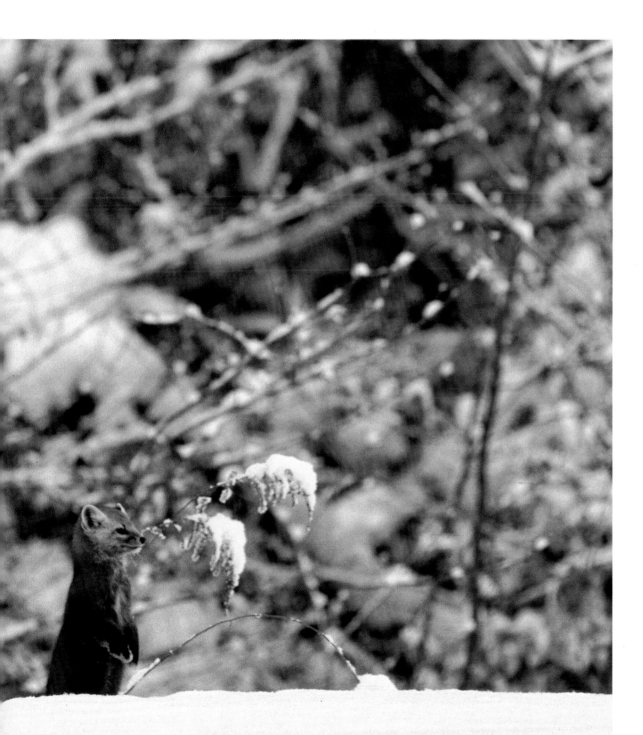

The snows of winter render a silent beauty to the Algonquin landscape. Throughout this season of cold, rigorous challenges confront all animals that remain active. Predators, such as this marten, must battle starvation, as well as the inclement weather that frequently arises.

Snows may fall as early as September but seldom remain for long. A more permanent covering does not develop until late November or early December.

B
Y LATE NOVEMBER, frozen waters glisten beside hills of naked hardwoods. A thin crust of white now adorns the forest floor, emphasizing the rugged, dark projections of underlying rock. Exhaustedly celibate after the promiscuity of the rut, a majestic bull moose chews its cud as it lies upon the snowy carpet. Overhead, the shrill chirps of Evening Grosbeaks break the stillness of the frigid air.

A cold hush envelops the hardened land as winter slowly descends. The bounty of earlier seasons has been largely exploited, and the creatures that remain must search hard to find sustenance. Like tumbling leaves tossed by a gust of wind, a mixed flock of chickadees, nuthatches and creepers flits through bare branches. Living separate lives throughout the nesting season, these strangers now band together loosely in search of

dormant prey. The groupings are not simply social gatherings, but may confer necessary skills for winter survival: more eyes render foraging more successful and, at the same time, are more likely to detect the presence of dangerous foes.

With much of their prey either gone or securely asleep deep in sub-terranean chambers, predators must adopt new hunting strategies. Some, such as Northern Goshawks, may in certain years abandon the Park in search of richer sites. Others, such as timber wolves, simply increase the size of their hunting grounds. Wolf pups now travel as part of the pack, the frivolity of infancy necessarily discarded. Prematurely thrust into adulthood in this uncompromising world, few will survive the grueling challenges and live to savor the following spring.

As winter snows deepen and temperatures plunge, all life is taxed to the limit. Moose move to denser coniferous cover where food is more plentiful. Here, winter's harshness is somewhat diminished, for the thick canopy of evergreen needles traps heat and reduces the amount of snow that reaches the ground. On the coldest nights, when the swollen trunks of hardwoods crack explosively, shattering the dark with rifle-like volleys, Ruffed Grouse dive deep into the soft bed of white, seeking warm refuge from the elements above.

Although winter appears each year with vexatious regularity, the life that typifies this season is not always so predictable. Some years an early morning snowshoe trek brings one into a world teeming with restless activity. Everywhere, twisting waves of shrieking Pine Siskins flow from tall hemlocks while endless flocks of White-winged Crossbills swirl around the tops of cone-laden spruces. Yet, on other occasions, one is rewarded only by a scathing scolding from a distant red squirrel and a tight glow on the cheeks from the stinging fresh air. Much of the life that dominates winter landscapes is either transitory in nature or oscillates greatly in numbers from year to year.

The number of animals that brave an Algonquin winter depends on the accessibility of food resources, the availability of which varies

tremendously. The seeds of trees and shrubs, important food for many small mammals as well as birds, are almost non-existent some winters. Yet, in other years, the trees are laden with massive or "mast" crops. These support innumerable roving finches, which feast on the tiny seeds housed within the scales of cones. In years of low seed production, the woods are devoid of these nomadic birds.

Northern finches are not the only animals whose fate depends on the production of seeds. Small mammals, including red squirrels and deer mice, explode in population in years of prolific seed production and crash in numbers when the bearing of fruit is at a low. In turn, these small mammals are the food of larger animals, which, unlike the mobile finches, are unable to leave Algonquin in search of more numerous prey. Predators such as martens and red foxes necessarily face winter under a feast-or-famine principle, and in years of low prey density may succumb to starvation. Thus, for all hunters, whether the prey be a scurrying vole or a dangling cone, the magnitude of summer's seed crop ultimately dictates whether these marvelous creatures survive the rigors of an Algonquin winter.

Whenever an animal perishes from starvation, predation or an accident, others eagerly exploit the remains. The presence of a corpse is announced by the wrenching screams of Common Ravens. Whether the meal be scraps of a wolf-killed deer or the untouched bulk of a tick-encrusted moose, the ravens feast frantically. The harsh yells of vagrant juvenile ravens entice more to the booty, and also draw the attention of other scavengers within hearing. Both Bald and Golden Eagles, not known to nest in the Park, frequently join the feeding frenzies, their hulking frames dwarfing the noisy black mobs. Gray Jays, though their stashes are still well stocked, fill up on the meat and create new stores.

Even the most effective predators will not pass by a carcass. Wolves, foxes, martens and fishers readily glean essential nutrition from the cold-hardened flesh. There is never waste when an animal falls victim to the perils of winter. The death of one spells life for many.

An Algonquin winter imposes a cruel test of survival on all. However, its savage face presents an inspiring beauty not found at other times of the year. On a clear day, when the temperature fails to rise above minus twenty degrees Fahrenheit (minus thirty degrees Celsius), the bottomless blue of an unclouded sky envelops the snow-enshrined spires of evergreen balsam firs. The crunching of snowshoes through a smooth, crystalline carpet is the only sound that disturbs the deep silence. While on a winter trek one cannot help but feel completely alone, isolated in this wonder world of cold and snow.

The severity of February abates and fades slowly under the healing touch of March. As the sun burns stronger, the weight of winter's residues begins to lift from the land. Ruffed Grouse devour the swelling buds of poplars and birches, and Gray Jays begin their ageless search for nest materials.

Once again, the severest of the Algonquin seasons has run its course, and the consummate cycle begins anew.

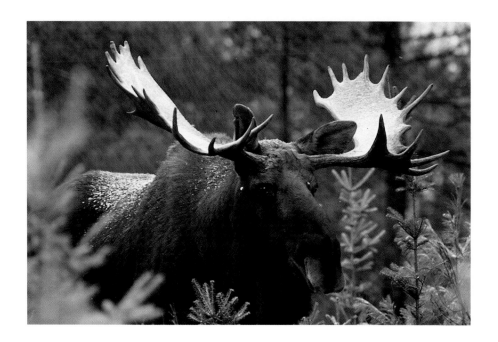

Balsam fir is one of the most important winter foods of moose in Algonquin and through much of the animals' eastern range. Both needles and twigs are browsed.

Although younger animals might retain their small antlers until March, large bulls generally have dropped theirs by January. It is beneficial to a bull to lose the rack for the antlers are heavy (a large set can weigh more than sixty pounds; twenty-seven kilograms), requiring considerable energy to carry, and they no longer serve any real purpose once the rut is completed.

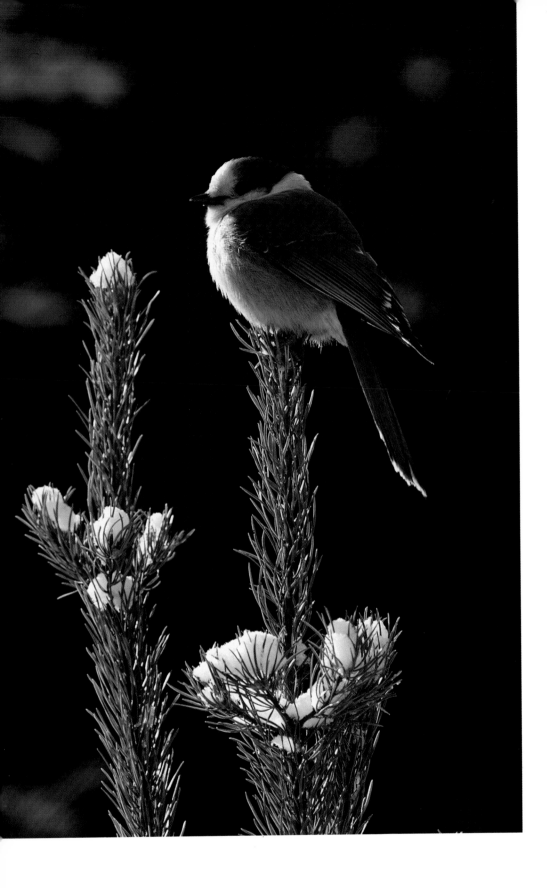

Food resources fluctuate from year to year, resulting in feast or famine for many animals. Gray Jays have resolved this problem by feeding on caches of food stored through the previous seasons. Many of their countless stashes likely are either exploited by other animals or are simply forgotten during the lengthy winter.

Eventually, a thick layer of snow covers all of Algonquin. Even the rocky talus slopes below cliffs are smoothed by this blanket of white. Although the snow appears to smother the landscape, it is vitally important for the survival of many of Algonquin's smaller inhabitants during bouts of bitter cold.

The term "blanket of snow" is quite appropriate for this covering. It not only benefits dormant animals by trapping heat near the surface of the ground but also provides a warm environment for a number of active animals. A small gap known as the subnivean space exists between the ground and the snow. A number of small animals roam throughout this relatively balmy region during the winter. Here, temperatures average only a few degrees below freezing.

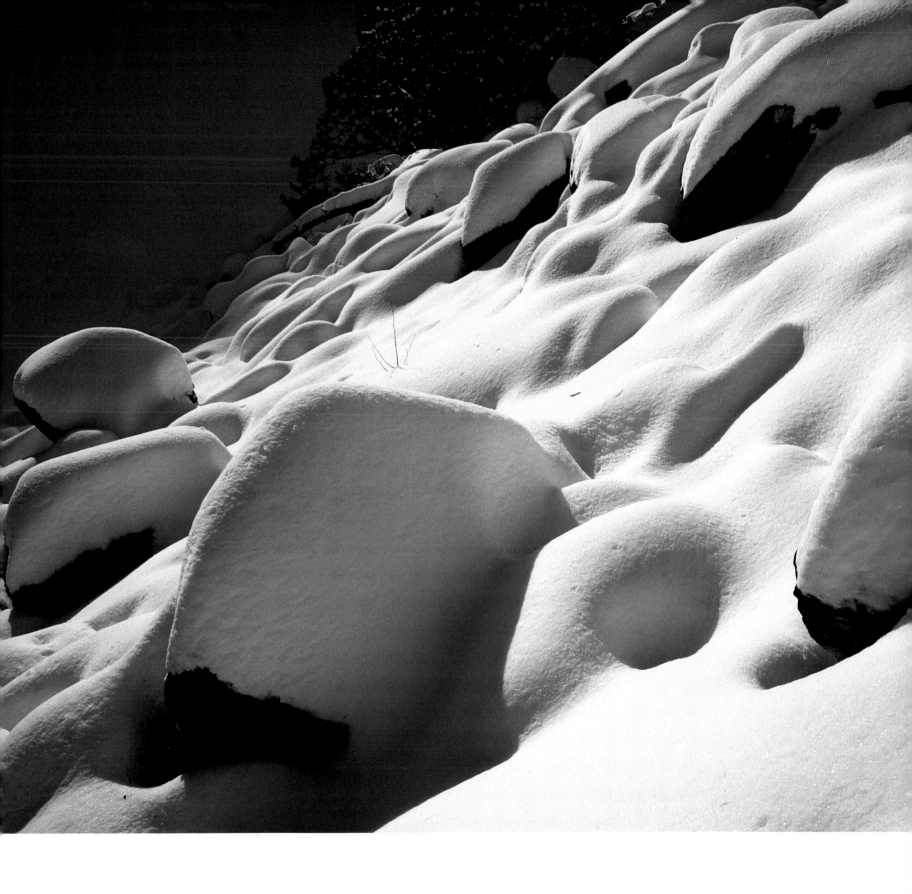

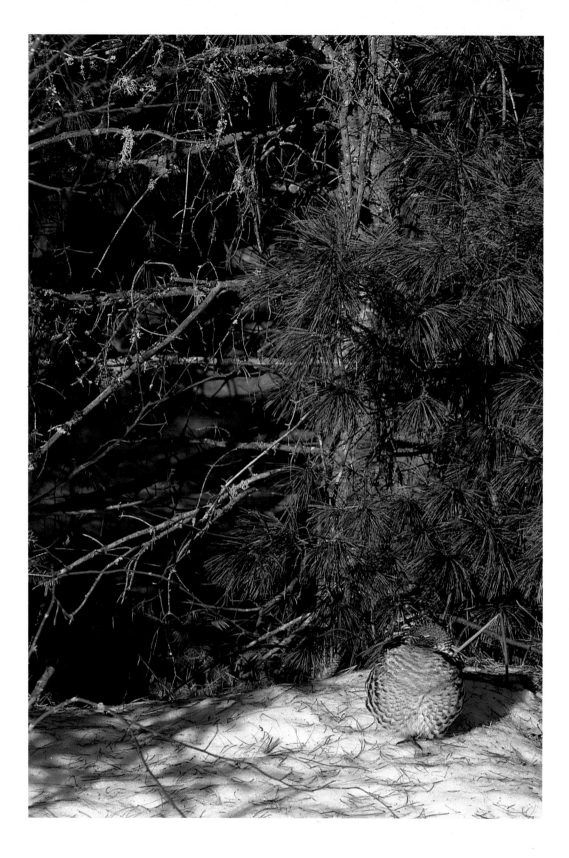

On cold days birds shiver almost constantly to generate heat. They also fluff their feathers to trap heat-retaining air. Ruffed Grouse and other birds absorb the gentle heat of sunlight by basking quietly in a sheltered place.

Mammals that are active in an Algonquin winter sport a thick and luxurious coat of hair. Fat reserves built during the fall also help to keep them warm. In addition, a special layer of brown fat that surrounds the internal organs is used to generate heat internally.

While the cold seldom poses much of a threat, a scarcity of food is one serious problem with which predators, including red foxes, may have to contend.

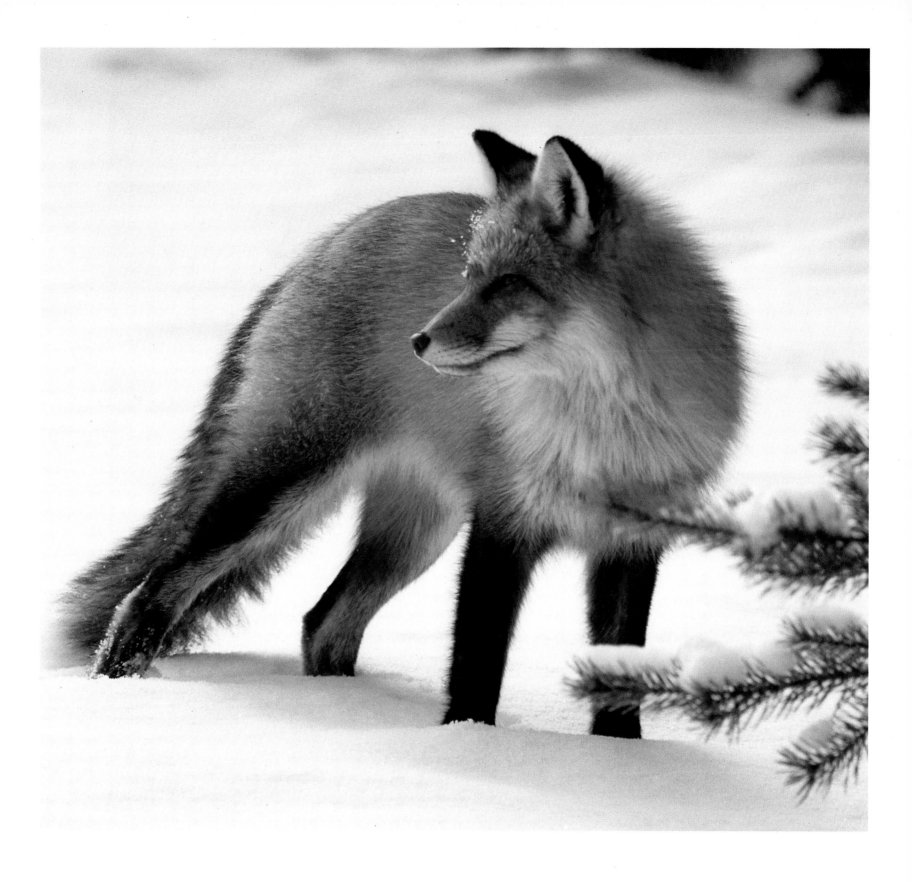

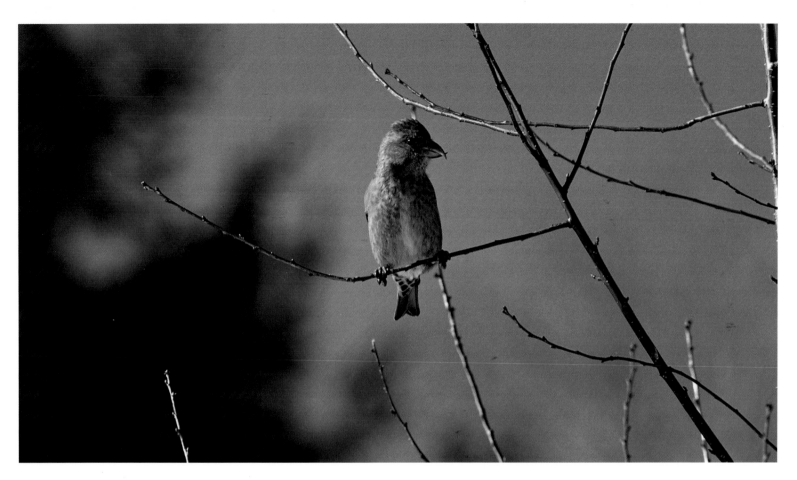

One of the more unusual of the Park birds, Red Crossbills can be found through most seasons in the pine forests on the eastern side of Algonquin. As its name suggests, the tips of the bird's bill actually cross over each other, serving as a specialized tool for opening cones. The crossbill's objectives—the tiny seeds of pines—are embedded at the base of the overlapping scales that cover the cone. By inserting the bill between the scales and opening its beak sideways (not up and down as most birds do), it pries open the scales for access by the agile tongue.

During winters when large numbers of northern finches invade Algonquin, the roads are often alive with foraging flocks. Although not searching for seeds, these birds are picking up particles important to their diet.

Seeds must be thoroughly ground before they can be digested, and pieces of grit are swallowed as an aid to this process. In addition, these birds lack salt in much of their diet, and pieces of road salt may be ingested as well.

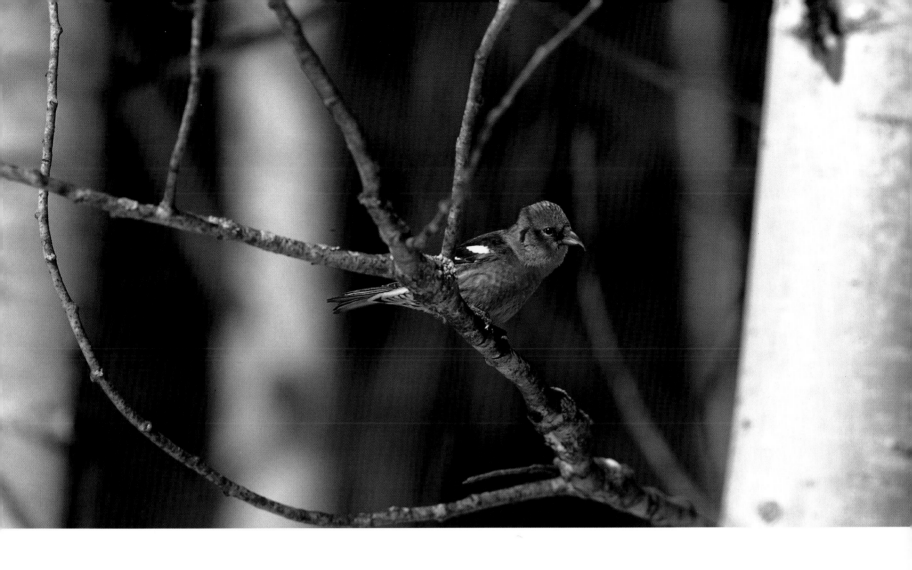

As is the case with most Algonquin birds, the male White-winged Crossbill bears much brighter colors than does the female. These crossbills, smaller than Red Crossbills both in bill and body size, specialize in feeding on the seeds of spruce and fir. Both types of crossbills fluctuate greatly in number from year to year, following the cycles of the seeds on which they feed.

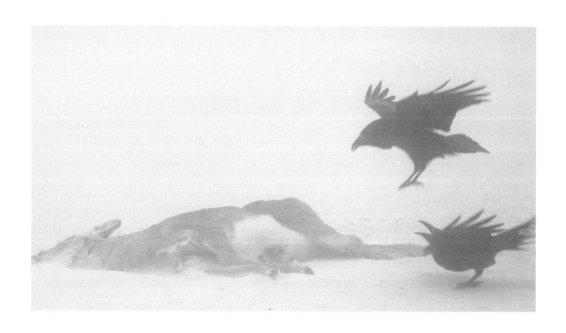

In winter, ravens are dependent on the misfortune of others and exploit any carcass encountered. Although only one pair of adults resides in any one region, large flocks of wandering juveniles eventually discover a corpse. The larger groupings allow for the establishment of dominance hierarchies, with almost continuous displays of aggression and submission.

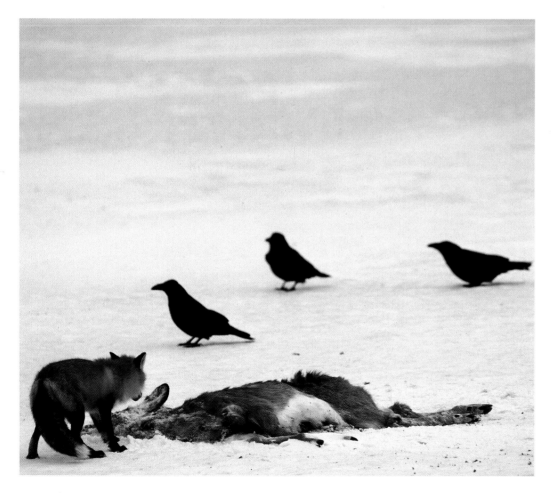

The din created by the crowd of ravens frequently alerts other scavengers to available bounty. Whenever a predator, such as this fox, approaches the carcass, the ravens retreat cautiously and nervously wait for the intruder to leave.

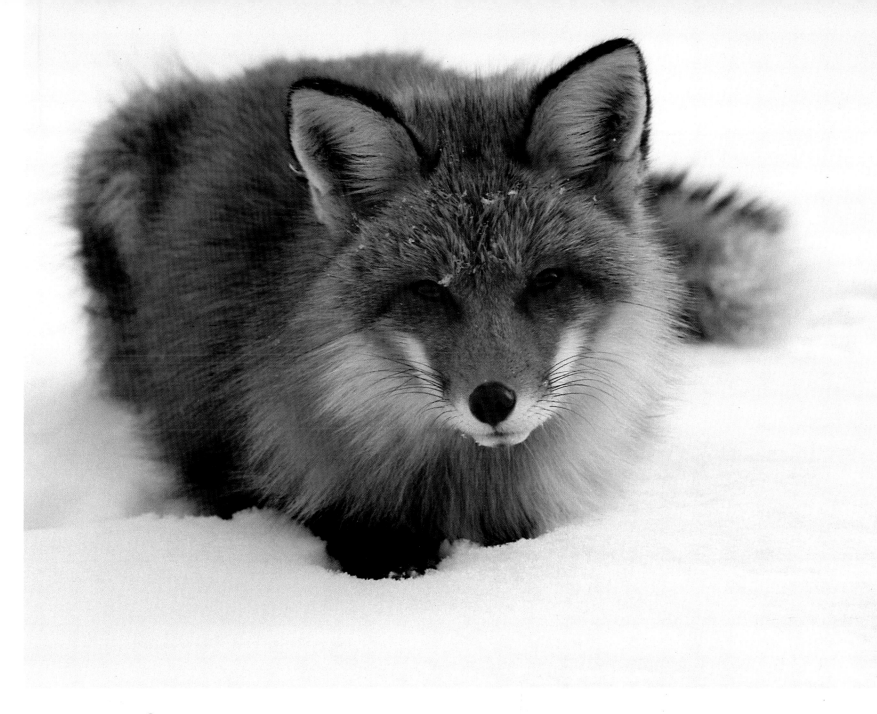

Of all the animals that brave an Algonquin winter, predators face the most demanding of challenges. To locate prey, tiring miles may be traveled through difficult terrain. When a potential meal is eventually discovered, the predator does not always

eat, for more often than not the prey escapes. Hunters are sometimes injured as larger quarry may fight back. Often many long, hard days pass before the rewards of the hunt are finally realized.

Succumbing to the effects of starvation, accidents and disease, many of these fascinating creatures never survive to enjoy the relief that spring brings.

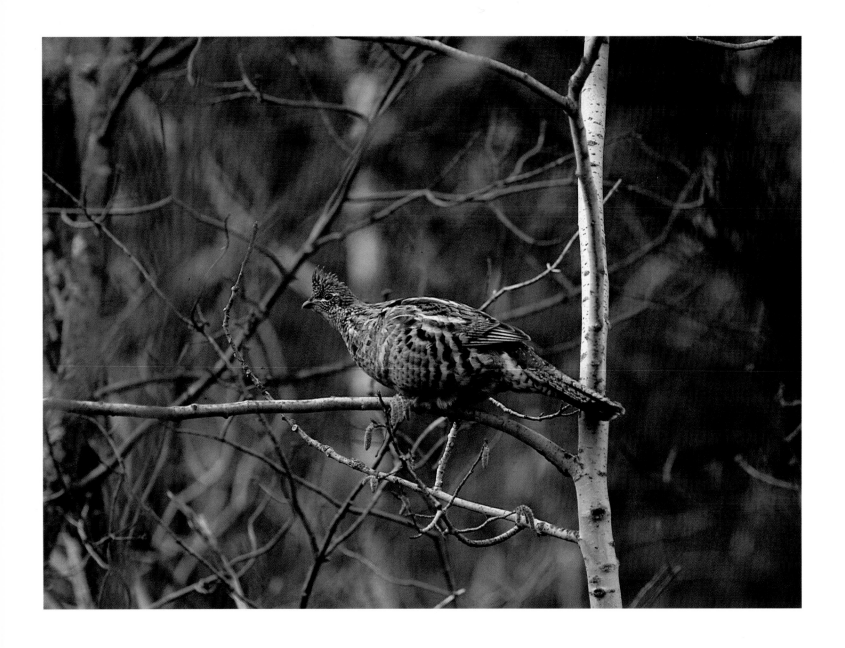

New resources appear with the length-
ening of the days. The swelling buds of
poplars and birches are eagerly de-
voured by Ruffed Grouse. Late in the
day these birds can easily be seen
perched high in the trees, "budding"
away.

As winter slowly passes, the days
gradually lengthen and warm. When
nighttime temperatures plunge after a
particularly warm day, the trees and
shrubs become covered in a shimmer-
ing frost.

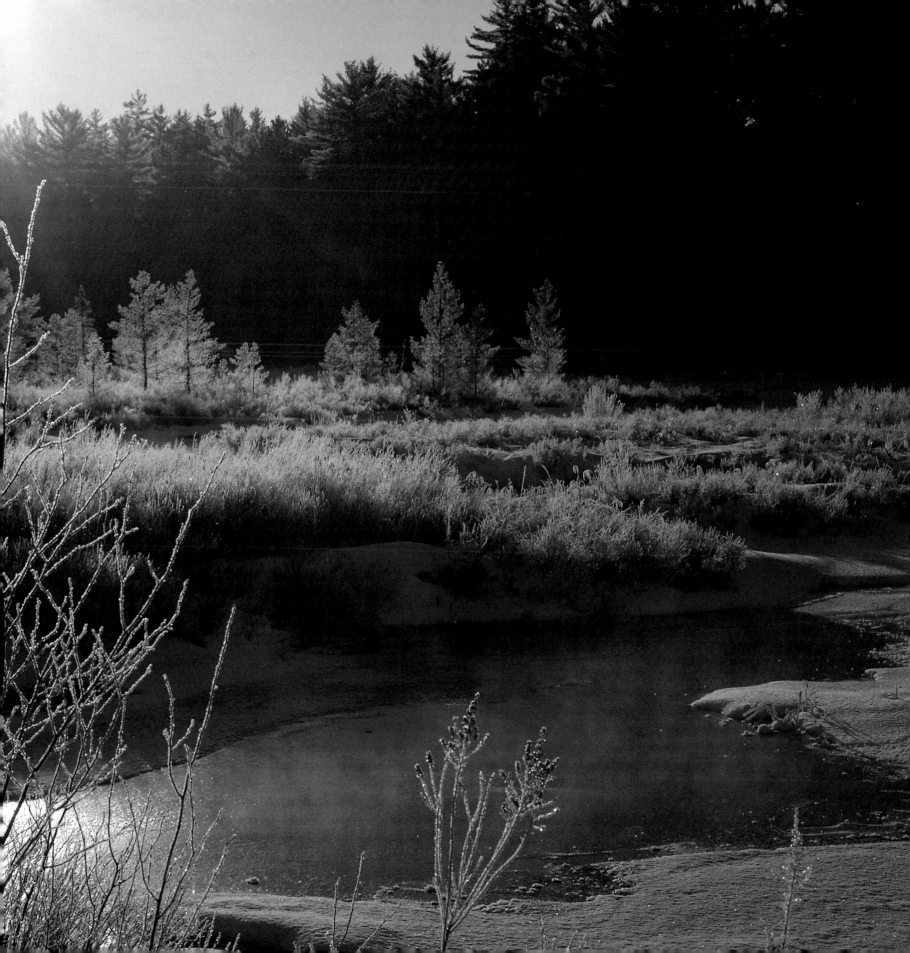

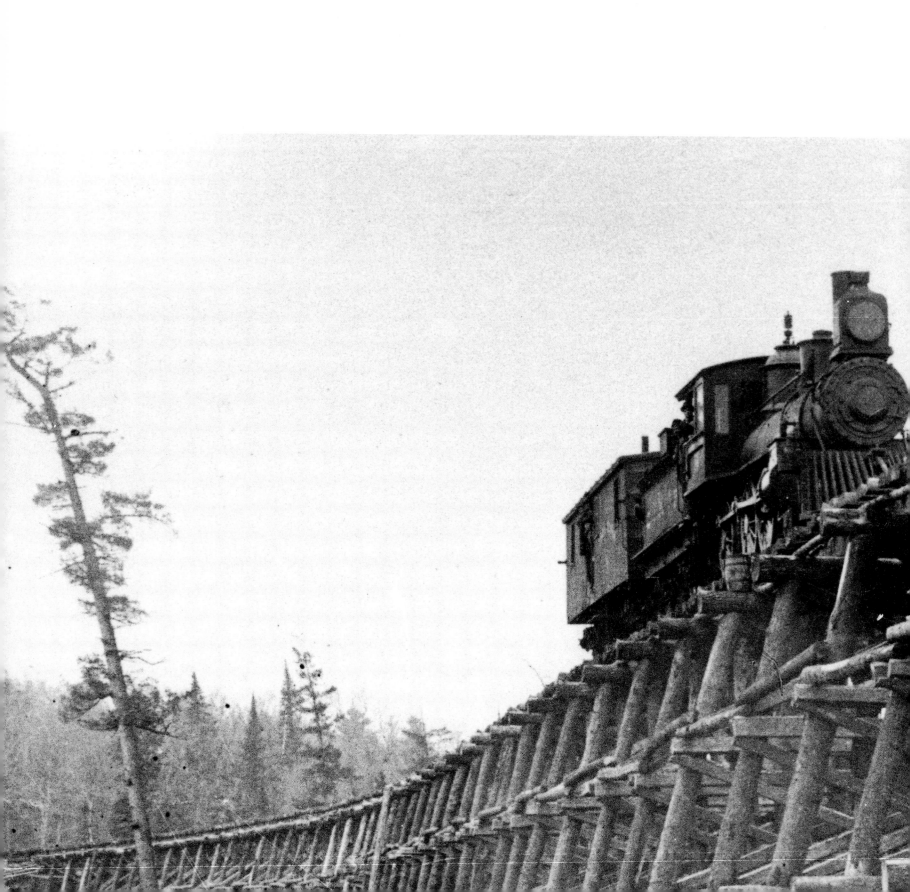

CHAPTER FIVE

Window to the Past

In 1896, the Ottawa, Arnprior and Parry Sound Railway was completed. Elaborate trestles, such as this one on Islet Lake, spanned larger waterways in Algonquin. (J.W. Ross)

Tom Thomson, one of Algonquin's most talented visitors, not only captured the park's moods and scenes on canvas but also frequently succeeded on his beloved fishing excursions.

(TOM THOMSON MEMORIAL GALLERY)

As one explores the infinite complexity of Algonquin Park, signs of powerful changes in the past soon become apparent. Charred remnants of ragged-topped stumps, decaying timbers in overgrown clearings and the vestiges of forgotten railway beds are obvious testaments to man's impact on the Park.

More subtle evidence of earlier human visits endures at several locations. Faded images stained on weathered cliff faces, moss-covered rock pilings on a hardwood plateau and jagged stone implements scattered through sand beaches are records of previous inhabitation by successive Indian cultures. These natives lived nomadically through the region up to several hundred years ago, never occupying this area in large numbers, and having little impact on the land. The same cannot be said of

the later influx of non-natives, who also came to exploit the area's resources.

Exploration of the Algonquin region was initially conducted under the auspices of the British Army. Excursions led by Lieutenants Briscoe in 1826 and Walpole in 1827 were, in part, designed to search for a new water route to the upper Great Lakes. Although their journeys took them along the same routes enjoyed by present-day canoeists, the Algonquin forests that these early explorers encountered differed considerably from the forests of today.

Throughout the western uplands, towering white pines thrust their sweeping branches above the crowns of the surrounding hardwoods. These giants, often exceeding one hundred and thirty feet (forty meters) in height and five feet (one and one-half meters) in diameter, grew as scattered components of the western forests but alongside the red pines formed more solid stands over the sandy plains of the east. These very trees drew the first rush of men into the far reaches of the Algonquin region, not to admire the stately growth but to rape the land of its bounty.

In the early 1800s England desperately sought new sources of timber for building her fleets, for Napoleon had cut off her supply of wood from the Baltic. The New World forests offered a suitable alternative. Eventually, Algonquin's forests, with their seemingly inexhaustible quantity of flawless trees, became part of the supply. By the late 1830s the removal of the pines had begun. Felling, initially only by axe but later by saw, was done primarily in winter, and the downed trees were transported by horse-drawn sleighs to frozen lakes. With the arrival of spring, the logs were carried by swollen rivers, principally the Petawawa, Madawaska and Bonnechere, to the mighty Ottawa. From here, lashed onto huge rafts and propelled by wind and current, they began an arduous journey to the St. Lawrence and ultimately to the docks at Quebec City.

Loaded into the hulls of timber ships, the precious cargo faced one last challenge before its arrival in Great Britain. The Atlantic Ocean, with its surging waves and crushing swells, would easily capsize an

unbalanced ship, resulting in the loss of both wood and life. It was critical to pack the timber as compactly as possible, thereby reducing the risk of a shifting load. The best way of doing so was shipping logs that had been squared.

The squaring of the timber was done in the Algonquin highlands, as soon as the towering trees were felled. The process of removing the outer layers with axes may have provided for more efficient packing of the timbers at Quebec City, but it also resulted in a phenomenal waste of material — up to half of the tree in some cases. The discarded bark and slash were left in piles which, when dried, fueled raging fires that severely scarred the Algonquin landscape.

As the exploitation of the largest virgin pines in the Algonquin region was nearing an end, southern parts of the province were experiencing a much more rapid depletion of the forests and wildlife. Many Ontarians were concerned that part of the province's wilderness should be set aside as a preserve before it was entirely destroyed. Born of the rugged Canadian Shield, which scorned attempts at farm colonization over its inhospitable expanses, the Algonquin highlands represented one of the last of the wilderness regions. Also, these forested highlands were the origin of half a dozen major rivers, as well as being the source of the flourishing timber trade. Thus, in 1893, primarily through the efforts of Alexander Kirkwood, Chief Clerk in the Land Sales Division of the Ontario Department of Crown Lands, and James Dickson, Ontario Land Surveyor, Algonquin National Park was born. In recognition of Algonquin's significance, the word "national" was originally part of the title, even though the Park was always under provincial jurisdiction. Not until 1913 was the word replaced with "Provincial."

Initially, the waterways provided the primary means of access into the Park, as well as the sole means of log transport out. However, an enterprising lumber baron, J.R. Booth, was to set upon a course of action that not only would vastly improve access to and transport from

Algonquin but also would open up the Park to further, dramatic change. Only a year after the Park's inception, Booth began the construction of the Ottawa, Arnprior and Parry Sound (O.A. & P.S.) Railway across the southern portion of the Park. The incredible feat of passing a line of steel over bottomless bogs, through unyielding rock faces and over winding rivers was accomplished in a mere three years, all before the turn of the century and the advent of more modern construction techniques. The O.A. & P.S. became an important link between the east and the west, providing a new means of timber export from the Park and the shipment of grains from Georgian Bay ports to markets in the east. It would become a busy track.

The supply of giant trees that first drew the lumber trade, and later, indirectly, the railway to the area, was for the most part gone by the end of the nineteenth century. Fortunately for the lumber people, a new market had developed in the United States. Sawn lumber was eagerly sought due to rapid expansion into the American west. Ignored by the first loggers, smaller trees now were exploited throughout Algonquin. The railway could be used for the movement of raw materials to sawmills in the Ottawa Valley.

Despite the presence of the railway, however, rivers remained important in the transport of logs. The size of trees harvested for this market was considerably smaller and the process of squaring no longer necessary. Nevertheless, the sawlogs were still transported to the Ottawa River in the same fashion as the squared timber. The river drives were treacherous for both logs and rivermen, for numerous wild rapids and churning falls lay between the starting-points and the Ottawa River. Many of these obstacles were bypassed through wooden chutes, but log jams were still frequent and untangling them was difficult and dangerous. Along the banks of these untamed rivers unobtrusive graves reflect the seriousness of the risks.

The railway may have been built with the goal of creating a transportation network between the east and west, but its effect on

Algonquin went far beyond the movement of inert materials. For the first time, easy access was afforded to those who desired recreation in a wilderness setting. Townsites, such as Mowat on Canoe Lake, now attracted seasonal visitors, as well as people who came to work for the lumber industry. Along the line, lodges began to appear, catering to more refined Park users. Highland Inn on Cache Lake, Hotel Algonquin on Joe Lake and Mowat Lodge on Canoe Lake are a few of the lodges that appeared along the O.A. & P.S. line early in the twentieth century. Another line, the Canadian Northern Railway (later to become part of the Canadian National Railway), provided access to the northern reaches of the Park in 1915, and along its length, lodges bearing such names as Lake Travers, Wigwam and Kish-Kaduk were erected. In addition to the train stations near the lodges, other stations throughout the Park offered canoeists and fishermen launching points for their memorable trips.

With the railway came a new type of Park user. Burly, unwashed woodsmen were now outnumbered by cleancut, suit-wearing gentlemen and white-gloved, hat-bearing ladies. The Park's fame as an outstanding recreational area for fishing and canoeing grew. Summer residences began to spring up on lakeshores as leases became available. Influential citizens from both Canada and the United States began to call Algonquin their second home. The natural beauty of the Park, albeit altered greatly over the previous century, caught the eye of Canada's artistic community, and Tom Thomson and his associates (including those who after his death banded under the name "the Group of Seven") began to record the many moods and images of Algonquin. Thomson lived in the Park as a fire ranger and guide, and between 1912 and 1917 (the year he mysteriously drowned in Canoe Lake) produced some of his most famous works, including "Northern River," "West Wind" and "Jack Pine."

The Park finally became more accessible to the average person when Highway 60 was extended through its southern part in the mid-1930s.

Cars, formerly confined to the upgraded railway spur line from Whitney to Opeongo Lake, could now be driven right across the Park. With the influx of vehicles (three thousand, six hundred during the first year of the highway operation), public services such as campgrounds began to spring up along the highway corridor. While the opening of the highway served to enhance public access, it undermined visitor dependency on the railway. The Canadian National Railway, which took over ownership of the O.A. & P.S. in 1923, had its service across the southern part of the Park severed in 1933. Ultimately, all services to this region of Algonquin were discontinued by 1959. The highway thus emerged as the primary source of access to the Park.

Over the past sixty years, Algonquin has grown not only in physical size (due to additions of adjacent lands) but also in visitor use and available services. The Highway 60 corridor remains the most-used source of access. Along this route are nine major campgrounds, seven picnic grounds, two museums, an outdoor theater, thirteen interpretive trails, four cross-country ski trails and two backpacking trail complexes. The highway is also the most important starting-point for canoeists, and two outfitting stores and canoe centers are also situated in the corridor. A complex network of canoe routes with well-marked campsites and portages has been established throughout the Park interior. Additional access roads have been established around the perimeter, and campgrounds and interpretive trails are located in both the northern and northeastern reaches of the Park.

Increased demands on Algonquin have given birth to a complex set of conflicts. The logging industry, recreational users, commercial ventures and native peoples all want something out of the Park. To resolve the conflicts, an Algonquin Park Master Plan, which identifies specific activities and dictates where and when they will take place, was released in 1974. A second Master Plan Review, with recommendations to amend certain aspects of the present Park regulations and

designations, was released in 1990. Visitors in the future may well encounter a completely different framework of regulations and activities.

Through the years, Algonquin has suffered many indignities at the hands of its human visitors. However, despite numerous attempts to alter its outward appearance, the heart and soul of this magnificent Park remain unbroken. Gone is the crashing of logs during the frenzy of a spring drive, but the mournful wails of loons continue to fill the night air. As one leans back from the heat of a crackling campfire and becomes absorbed by the whispers of the wind stroking the pines, time loses all relevance — exactly as it did a hundred years ago when a tired lumberjack found solace in this same captivating song.

The first rush of visitors to Algonquin came not to admire the inherent beauty of the land but to exploit the towering white pines. (ONTARIO MINISTRY OF NATURAL RESOURCES)

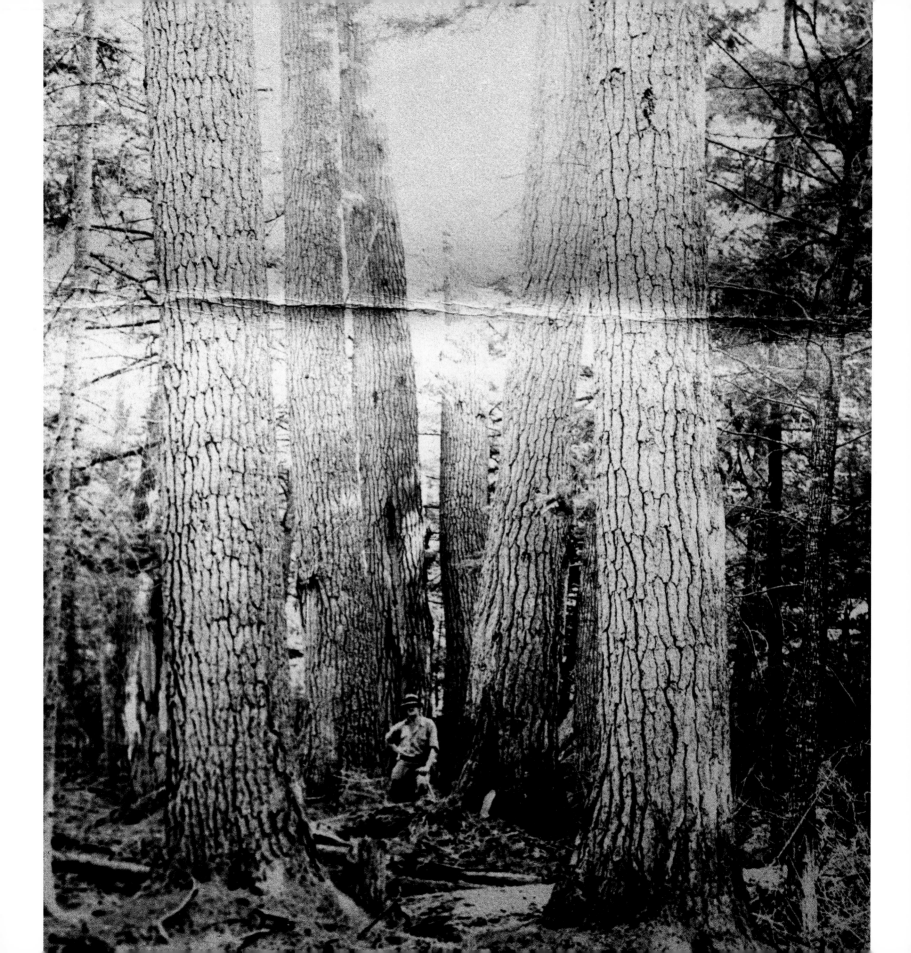

After the outer layer of the trees was removed by the scorers, further trimming with broad axes squared the pines, in some cases reportedly as smooth as a table top. While the squaring allowed for more efficient packing of timbers onto ships at Quebec City, it resulted in a tremendous waste of resources.

(Ontario Ministry of Natural Resources)

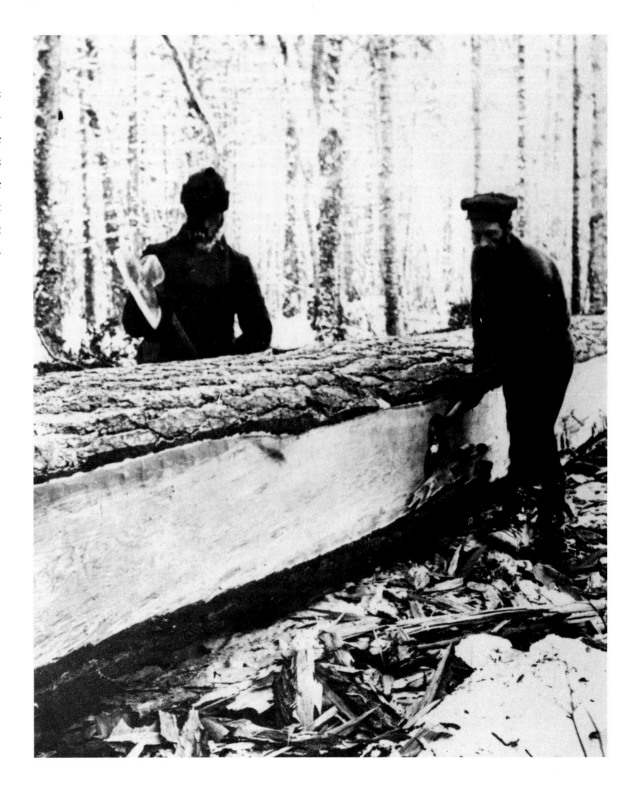

The lumber baron J. R. Booth, here in his ninety-eighth year, was responsible for bringing the railway to Algonquin. (L. NEWMAN)

While most wildlife was protected when the Park was formed, wolves were not. Under the mistaken impression that wolves were detrimental to wildlife populations, Park rangers such as Bob Balfour (on the right) used poison, guns and snares as means to destroy them. Finally, the much maligned animals received protection in 1958 when a wolf research program began. Algonquin is now famous for its wolf population.

(R. Thomas and J. Wilkinson)

The arrival of Highway 60 opened Algonquin to a flurry of eager visitors. Prior to the completion of the highway in the mid-1930s, the railway spur line running between Whitney and Opeongo Lake offered the only access by automobile. Along this earlier route a party enjoys lunch "à la canoe."

(ONTARIO MINISTRY OF NATURAL RESOURCES)

Algonquin gained fame as a wildlife viewing area. White-tailed deer, formerly abundant all through the Park after the clearing of the forests by man and fire, were commonly encountered along the highway. As the forest matured with stricter controls on logging and fire, deer decreased in numbers. However, a semi-tame group, fed by residents of the Highland Inn, remained in the Cache Lake vicinity. Even after the lodge was demolished in 1957, this herd persisted for years and wandered along the highway seeking handouts from willing tourists.

(ONTARIO MINISTRY OF NATURAL RESOURCES)

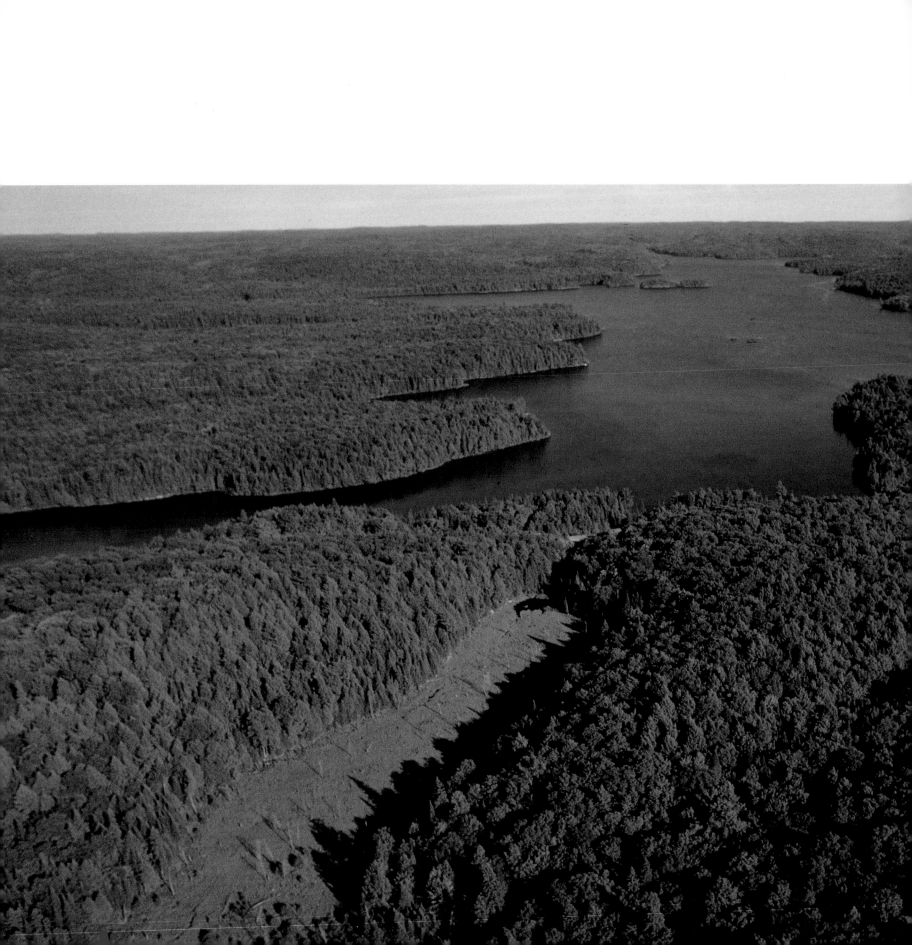

Impressions

Algonquin's immense size is only one of its many attributes.

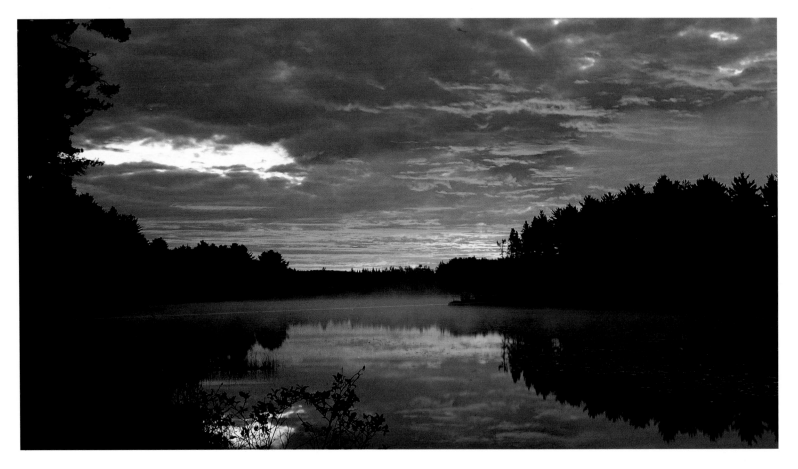

To some, as it was to Tom Thomson and members of the Group of Seven, Algonquin Park is a visual symphony of color and form. The autumnal blaze of hardwoods against a cold, blue September sky; the vibrant flood of spring wildflowers carpeting a sun-drenched forest floor; the living web of lichen and fern dripping from the ancient face of a lake-embracing cliff; the glowing mists of late summer rising into the dawn — one or all of these images may stand out in their memories.

To others, the Park is the living creatures that flourish in its forests and waters. These visitors remember the splash of a Great Blue Heron snaring its slippery prey; the mirrored image of a mighty bull moose feasting in a quiet pond; silver droplets of water cascading from the

head of a just-emerged loon; the barrage of a cheeky chipmunk dominating a campground meal.

But to me, as well as to many of its patrons, Algonquin is much more than a collection of individual components. For those who have floated in a canoe on a mist-shrouded lake as loons serenade the awakening day or have lain spellbound under the contorted dance of Northern Lights while a distant wolf's mournful song fills the soul, Algonquin reveals itself as the aura of a living being. From atop every windswept cliff and around every bend of a winding river, through the scorching heat of summer and the bitter cold of winter, its presence can be felt.

Those of you who have been to the Park are undoubtedly anticipating a return trip. I cordially invite those who have never been to come visit this magnificent Park and meet first-hand the great wild spirit we call Algonquin.